CONTENTS

1 PAINTING AND DYEING

13

2 COLORS IN THE MIDDLE AGES

39

3 THE EXPLOSION OF SUPPLY AND DEMAND

67

4 THE TRIUMPH OF INDUSTRIAL CHEMISTRY

97

DOCUMENTS

129

Further Reading

152

List of Illustrations

153

Index

156

COLORS
THE STORY OF DYES AND PIGMENTS

Françoise Delamare and Bernard Guineau

DISCOVERIES®

ABRAMS, NEW YORK

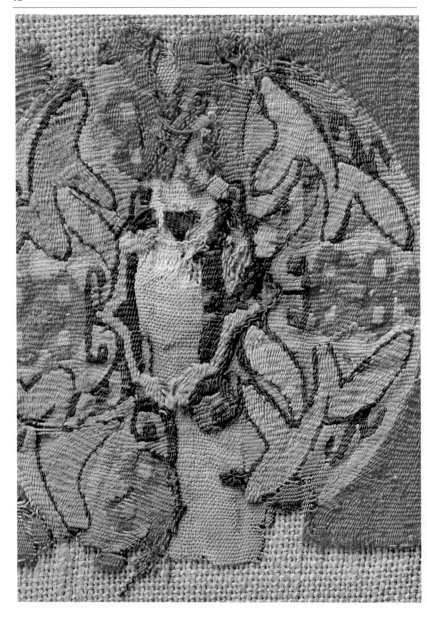

The world in which we live is teeming with color: the sky, earth, water, and fire all have distinct colors. From time immemorial, we who delight in such perceptions have tried to reproduce these colors in our day-to-day surroundings. What could be more normal? For color is the child of light, the source of all life on earth. The challenge of finding materials capable of producing lasting colors in the world around us has preoccupied humankind from prehistory to the present day.

CHAPTER 1
PAINTING AND DYEING

Tinted with the same warm tones, this Coptic textile (left) and Eye of Horus (right) seem to reflect the same techniques of color application. Far from it: the coloring of yarn requires dyes, while the painting of a surface uses pigments or lakes.

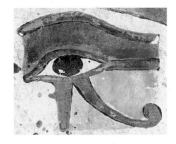

Where do colors come from? One might think that the rocks, plants, and animals with whom we share the earth could supply us with many coloring agents, but in fact few are suitable. The chlorophyl that gives vegetation its rich green yields, when extracted from the plant, is an unstable tinting agent that fades and disappears in a matter of hours. None of the vibrant colors of the peacock's striking plumage can be transferred to any other material. To try to do so would be like trying to extract the colors from a rainbow. Fortunately, nature abounds with a generous supply of other organic and inorganic substances, whose colors are extractable and transferable to a variety of supports. These include minerals such as yellow and red ocher, green earth (terre verte), white chalk, and lampblack. Thus we must distinguish colored materials from colorants. The latter—colors removed from one place and applied to another—were used for the first paintings, decorations, and dyes created by human beings.

An area near Apt, in France, has spectacular quarries of ochrous sand. Above: the quarry in Roussillon in the Vaucluse. Right: rock from Saint-Amand-en-Puisaye.

Natural earths

Colored minerals, earths and ochers, have been used constantly throughout human history. Used by all civilizations, earths lend themselves to a wide range of decorations, from decorating the body to painting on

natural or constructed walls. The colors they yield are extremely stable, which explains why they have survived to this day. They are never bright, but offer a wide range of tints and hues that give free rein to artistic expression.

Most natural earths get their color from the mineral iron, which is found abundantly in the earth's crust in a wide variety of tones: red and yellow ochers, green earths, and hydrated iron oxides of greater or lesser purity.

Ochers are the best known. These are mixtures of quartz sand, clay (kaolin), and iron oxide, with hues ranging from brown and yellow through red and violet. Technically, the name *ocher* is used only for the product extracted from ochrous sand by a process of fine grinding that eliminates the sand, leaving the finer grains of clay. Hematite, also called sanguine, is a red iron oxide (the names are from Greek and French words for blood); ochers that contain hematite crystals may be red-orange, red, and even red-violet. Ochers made with yellow iron oxide (goethite), on the other hand, are yellow alone. Goethite becomes hematite when heated, and it is possible thus to make red tints from yellow ochers, which are more abundant in nature. A small amount of manganese oxide mixed in with goethite produces the brown tones known as siena and umber. Earths in which manganese oxide predominates are black. All these natural earths are readily found in the valleys of France and Spain where the famous painted Palaeolithic caves of Lascaux, Pech-Merle, and Altamira were discovered.

The earth's crust abounds with iron oxides, ochers, and rubefied earths that may be used as pigments. Among the iron oxides, hematite and limonite are the most important. Hematite is a variety of the oxide Fe_2O_3. In rock form it is black with metallic glints, and earns its name (blood red in Latin) only when pulverized. Depending on the size of its granules, it produces shades ranging from violet-purple (0.5 microns) to red (0.1 microns) to orange (0.05 microns). Limonite is a rock whose color ranges from yellow to brown. It is made up of goethite and poorly crystallized gels. Rubefied earths are red earths formed when mother lodes containing iron are exposed to rain, resulting in the formation of hematite. Some, such as terra rossa, are used as pigments.

Colors before history: pigments

Pigments are pure colors in powder form, which must be suspended in a medium in which they are insoluble (such as oil) in order to make paint. Natural colors belong to the family of pigments. The size of individual powder particles varies from .01 to 1 micron. When greatly magnified in an optical or electronic microscope, individual particles of pigment may be seen suspended across the medium they color.

The use of colored earths is found in even the oldest civilizations. The first known pigments date to the early Palaeolithic period (350,000 BC). At this time, red earths were used to decorate the body: tattoos decorated the flesh of the living, while the bones of the dead were reddened with ocher. These earths, as well as manganese oxide and charcoal blacks, were also used for domestic purposes, such as the tanning of hides, preservation of food, and pharmacology. It is, however, difficult to date the development of uses over a very long period. Analyses of traces of color or bits of pigment in prehistoric sites have not been able to establish a clear sense of their evolution.

Many of the best sites for Palaeolithic artifacts are in France, in the valleys of the Dordogne and Lot. The use of yellow ocher appears in Arcy-sur-Cure and Yonne in the Middle Palaeolithic period, around 40,000 BC. Also dating to this period is the technique of heating yellow ocher to produce red. We do not know just how prehistoric peoples went about the fine-grinding operation, but it cannot have been all that different from the method used today. Ochrous sand separates into two

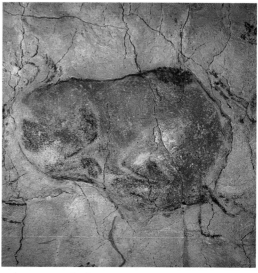

Below: as a bison suggests, red predominates in the prehistoric cave paintings of Altamira in northern Spain.

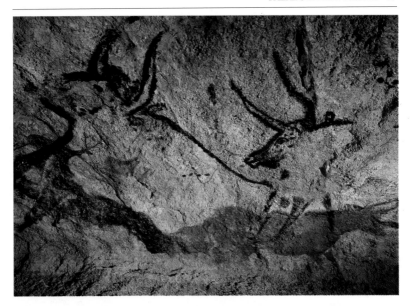

elements when suspended in water: the heavier quartz granules fall to the bottom, while the clay and colored oxide remain in suspension. This liquid is collected, and ocher is the residue obtained after evaporation. The finer it is, the more valuable.

Figurative painting appeared in Europe during the Upper Palaeolithic period. The palette of this early art was enriched with browns and whites, in addition to ochers. On the walls of the Lascaux cave in France (15,000 BC), for example, we find red and yellow sandy ochers, manganese-oxide browns and blacks, and calcite white. Red predominates at Altamira, in Spain (10,000 BC), where a hematite pigment with large crystals (hematite iron) is used. Samples of prehistoric pigments, gathered and analyzed from eleven prehistoric sites in Provence, in the south of France, indicate the use of a wide range of substances colored by iron oxides: pure hematite, red earth (terra rossa), bauxite (aluminous red earth), sandy ochers, and another iron oxide, maghemite. Where did these materials come from? Some are from close by, but others appear to have been brought from a

A form of pollution called the "green disease," caused by the proliferation of microscopic algae, almost destroyed the cave paintings in Lascaux, France. Fortunately, after research and treatment, this biological contamination was destroyed. Lascaux has more than a thousand paintings and incised drawings, as well as numerous other traces (some of them tiny) of the work and lives of Palaeolithic peoples.

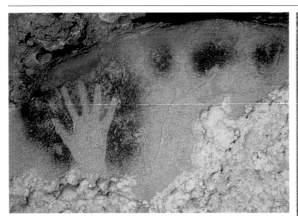

considerable distance. The chunks of pigment found by archaeologists have a rather varied composition. Provence has several small exploitation sites of sandy ocher, the oldest of which dates from the Upper Palaeolithic period. Substances extracted from one of these seem to match pigments found in decorations at a site 240 miles (400 kilometers) away. This may be an isolated incident; it is extremely difficult to trace a provenance for these families of ancient materials.

We note the absence of blues and greens in the ancient paintings. The first is understandable, given the rarity of blue minerals. But the second is much stranger, since types of green earth (terre verte) are found in great quantities in nature, and their colors are very stable over time. Perhaps their lack of luminosity made them unpopular; they would not have been very bright in caves lit by yellow torchlight or by the first oil lamps.

Early dyestuffs

Cloth is colored with another family of materials: dyes. Dyeing is the coloring of textile fibers or the surface of a textile. Dyes are soluble colored compounds suspended in a medium. They are organic (meaning that their molecules are carbon-based: plant or animal extracts) and react in very small quantities. The use of dyes is probably as old as that of mineral pigments, but since

The exact techniques used by the painters of the prehistoric caves are still debated. An analysis undertaken recently at Pech-Merle demonstrates that they prepared colors by calcinating and pulverizing them. These "negative" images of hands must have been created by blowing a colored powder from the mouth onto a hand pressed against the wall.

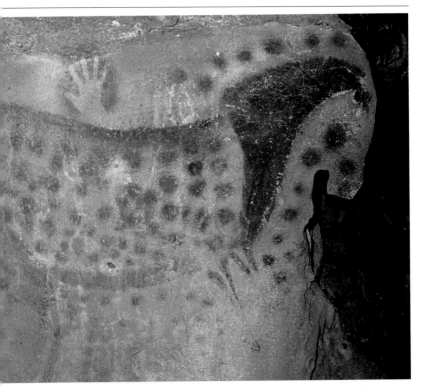

textile fibers are very fragile, few survive and concrete proof of this is lacking. The incomparable durability of the prehistoric mural paintings over the ages has facilitated their study, as well as that of decorated objects. But the oldest known dyed fabrics date only to around 6000 BC. Seeds of the weld plant, used for making a fine yellow dye, have been found in several Neolithic excavations. There are dyed textiles from lacustrine settlements in Switzerland, Provençal pastel dyed fabrics, and cotton fabrics found in Mohenjo-Daro, in the Indus Valley (2500–1500 BC). In Crete, murex purple dyes dating to 1600 BC have been found. Ancient textiles have survived best in the dry climate of the eastern Mediterranean, particularly Egypt.

The spotted horses in the French cave of Pech-Merle are a jewel of early parietal art. This painting, more than 25,000 years old, was gradually covered over time with a coating of hard-pan that perfectly preserved its original colors: red hematite, yellow ocher, calcite white, manganese, and lampblack. Colors and tracings are mixed and superimposed.

Egypt: 3,000 years of color

Among the ancient civilizations, Egypt is distinguished by its wide use of color. A wealth of decorated walls, painted objects, and equipment and materials belonging to painters and scribes survives, representing many thousands of years of the use of colorants. Colors in Egyptian paintings can be divided into two categories: those used for naturalistic purposes (landscapes and scenes from daily life), in which the painter mixed or super-imposed colors at will; and those used for religious purposes (funereal or medical artworks), whose palette was strictly limited to six colors. Each of these was charged with great symbolism and associated with a precious stone or metal (gold or silver). As with all symbolic colors, to mix or blend them would render them meaningless; hence, they were used only in juxtaposition to each other.

To the reds and yellows of prehistory, the Egyptians added dark and light blues, greens, violet, white, and gold. Ochers, however, remained the foundation colors used in temple decoration. A binder with a gum-arabic base, mixed with calcite white, was used as a preparatory ground for paintings. A distinguishing feature of the entire 3,000 years of Egyptian art is the ever-increasing diversity of supports used, which in turn engendered new painting techniques. In

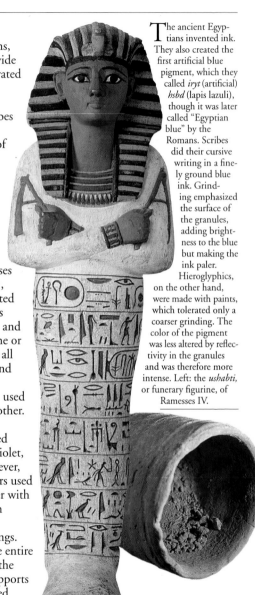

The ancient Egyptians invented ink. They also created the first artificial blue pigment, which they called *iryt* (artificial) *hsbd* (lapis lazuli), though it was later called "Egyptian blue" by the Romans. Scribes did their cursive writing in a fine-ly ground blue ink. Grind-ing emphasized the surface of the granules, adding bright-ness to the blue but making the ink paler. Hieroglyphics, on the other hand, were made with paints, which tolerated only a coarser grinding. The color of the pigment was less altered by reflec-tivity in the granules and was therefore more intense. Left: the *ushabti,* or funerary figurine, of Ramesses IV.

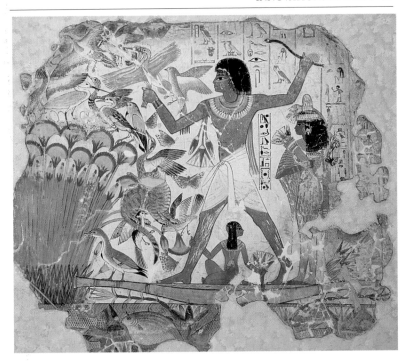

addition to the wall painting, inherited from prehistory, the Egyptians painted statuettes, wooden or alabaster boxes, panel portraits, sheets of papyrus, faience, and other objects intended to be held in the hand, as well as sarcophagi made of stuccoed pasteboard or wood. Each type of support required its own techniques: the proper preparation of the surface and the use of different binders to create the painting and ensure its durability.

Technical analysis has revealed the remarkable capacity for innovation of these artists and craftspeople. The Egyptian earth abounds in an unusual choice of minerals, which they exploited to the full. For red pigments they used arsenic disulfide, known as realgar, and in Lower Nubia red ocher as well. They made greens with

The naturalistic chromatic palette of Egypt is incomparably richer than its prehistoric kin. Similarly based on red and yellow ochers, it adds a blue, greens from copper salts, and a number of mineral colors, as can be seen in this stucco painting from the 18th Dynasty, c. 1400 BC. It depicts Nebamun hunting aquatic birds. Left: fragments of ocher and Egyptian blue found in the 18th-Dynasty tomb of the architect Kha at Deir el-Medina.

powdered malachite (basic copper carbonate) and atacamite (hydrated chloride of copper). But it is perhaps the yellows of Egypt that best demonstrate the inventive nature of these people. As early as the Old Kingdom (2700–2200 BC), in addition to the somewhat dull yellow of ocher, they used the golden yellow of orpiment (arsenic trisulfide; the name comes from the Latin: *auripigmentum,* gold pigment) and the pale acid yellow of the jarosites (minerals containing sulfates of iron, potassium, and sodium). All three pigments can be found together in some works, sometimes superimposed, such as on the Middle Kingdom coffin of the lady Henu (c. 1991–1786 BC; now in the British Museum). This wide range of yellow pigments long remained without peer in the West.

The first synthetic pigments

Another area of innovation in Egypt was that of synthetic pigments. Egyptian artisans were masters of the art of fire; among other things, they invented glass. Around the third millennium BC they perfected the fabrication of a synthetic blue pigment, a double silicate of copper and calcium that made up for the lack of natural blue minerals. This first synthetic was a resounding success. It could be manufactured in quantities great enough to decorate large objects and could be used in paints and inks. It was exported, and the Romans adopted it under the name of Alexandrian blue. When it

Opposite: this pendant, found in one of the coffers on the tomb of Tutankhamun, has the symbolic colors of the Egyptian religious palette, in this case made from precious stones and metals: gold, cornelian, turquoise, lapis, and malachite. Colors used in religious symbolism were never blended, but placed in juxtaposition.

Below: this hippopotamus, found in the 11th-Dynasty (2125–1985 BC) tomb of Intef in Abul Naga, has an extraordinary intense blue glaze. In the 19th century, European porcelain manufacturers tried to discover the recipe for it. Today it is identified as a copper blue, related to Alexandrian blue.

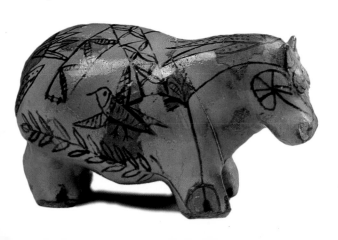

was mixed with sodic alkaline salts, the result was a series of spectacular blue faience glazes.

The Egyptians also manufactured a darker artificial blue, a green tinted with cobalt, ancestor of the famous Delft blue used by the Dutch to paint porcelain. Since deposits of cobalt are quite rare, many theories have been propounded regarding the origin of this synthetic. The cobalt appears to be indigenous, for certain salts (natrons) that have been found in salt lakes contain small quantities of it.

Texts from antiquity inform us that the same artisans who manufactured pigments also made medicinal preparations and cosmetics, and modern-day analyses confirm this. Kohl, for example, the black or dark gray cosmetic that the Egyptians used as an eye liner and to prevent eye infections, contains both natural pigments—galena (a black sulfide of lead) and ceruse (basic white lead carbonate)—and chlorides of artificial lead, used to reinforce the ophthalmic efficacy of the preparation.

Writing and painting on papyrus

Papyrus is a marvelous support material for both writing and painting, and it is no surprise that the Egyptians, who invented it, invented ink as well. The oldest known book dates to 2600 BC. This is the famous Prisse d'Avennes papyrus (named for its discoverer, the French

Orientalist Emile Prisse d'Avennes, 1807–79). Even older ink inscriptions have been identified on potsherds. The body of the Prisse d'Avennes papyrus is written in a black ink that is a very opaque dispersion of lampblack in water. Other Egyptian inks, red, green, and blue, are made with the same technique.

Ink must be more fluid than paint, and tends therefore to have less opacity. This is a lesser problem with black inks than with colored inks, and may be the reason for the universal use of black for writing. A version of black ink was invented in China about 3,000 years after the Egyptian. It used a different binder, based on hide glue, and its color is a matte black.

A bove: the text of the Prisse d'Avennes papyrus is written in black ink; red was used only for subtitles and chapter titles. The custom of using red ink for selected parts of a text, especially titles and subtitles, endured well into the modern era. The medieval term "rubric" (from the Latin *rubrica*, meaning "red ocher") came to designate the text that follows subtitles.

Textile dyeing

Because textiles are so fragile, few ancient examples of dyed fabrics have survived, and of these, few have been analyzed. Many dye-producing plants were to be found in ancient Egypt, but we possess few examples of their use. We do know that the madder plant was used to dye the red linen textiles found in the Old Kingdom tombs of the Nile Valley. Safflower, a source of red and pink, has been identified among the seeds found in the tomb of Tutankhamun. Should we trust ancient texts? Pliny the Elder, a 1st-century AD Roman encyclopedist, wrote a *Natural*

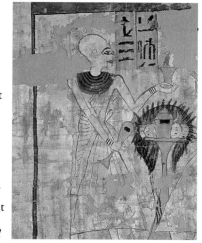

Inks can be paints or dyes, depending on the medium in which the pigment is suspended. Egyptian black ink was a suspension of ultrafine particles of lampblack in water, hence it was a form of watercolor.

Lampblack pigment is easy to prepare by incompletely burning oil or wood and then pulverizing it. However, it is difficult to suspend in water, for the particles become water-resistant and tend to clump, so that a smaller amount of pigmented surface is exposed. The Egyptians solved this problem by adding a binder to the water: a bit of gum arabic, which is a sugar. The sugar molecules, which are soluble in water, attach themselves to the surface of the lampblack particles, making them compatible with the water and preventing them from getting close enough to each other to clump. The resulting ink is black, shiny, and perfectly stable over time; it does not fade, and it is chemically neutral, so that it does not harm the support, as more acidic or basic inks may do.

History in which he reports that the Egyptian dyers used indigo, kermes (source of red or purple, made from parts of the cochineal insect), archil (a red-producing lichen, also called orchil or cudbear), alkanet (an herb whose root produces red), buckthorn berries and saffron (for yellow), mulberry juice (for red or purple), and tannins (acidic fixatives). According to Pliny, they also invented mordanting, a treatment of fibers with chemicals that allows the dye to adhere better, thus increasing colorfastness.

The Roman world

After the Greek conquest of Egypt in the Ptolemaic period (323–30 BC), the combined inventive genius of these two cultures increased. Rome was the beneficiary of the Greco-Egyptian inheritance, and proved efficient at disseminating the techniques of pigment manufacture and dyeing throughout the provinces of its vast empire.

The buried 1st-century AD Roman cities of Pompeii and Herculaneum were rediscovered in the 18th century. Their richly colored, beautifully preserved mural paintings created a sensation. Indeed, the freshness of the colors was so striking that the ancients were thought to have possessed great secrets. The most eminent chemists of the

Opposite: a painted linen shroud from the 19th Dynasty. Linen bears paint well.

time, influenced by the spirit of the Enlightenment, tackled this question. Studies of pigment chemistry in the ancient world were published in the early 19th century by Jean-Antoine Chaptal (1756–1832), Louis-Nicolas Vauquelin (1763–1829), and Sir Humphry Davy (1778–1829); these are among the first works devoted to archaeometry, the application of physical sciences to the study of ancient objects. Anne-Claude-Philippe de Tubières (1692–1765), a French archaeologist and collector of antiquities, pioneered this type of research. Archaeological discoveries in Roman Gaul (Vaison-la-Romaine, Vienne, Lero), and in Switzerland, Germany, and England, contributed further material for study.

Although the ancient Greeks had also made colored wall paintings and sculptures, very few examples have survived. But Roman murals are as abundant as the Egyptian. Most are frescoes, paintings done on a ground of wet plaster (*a fresco*), so that the paint is embedded in the ground. This difficult technique produces a durable artwork, but does not allow the painter to make any changes, nor to use certain pigments that do not interact well with plaster (lead white, realgar, orpiment, and indigo). The surface of the paint-and-plaster mixture hardens as it dries, so that the picture is sealed beneath a transparent, carbonized glaze. This surface can be very smooth, lending frescoes a resistant sheen.

Mural painting

The Roman Empire comprised a vast territory, from far western and northern Europe to North Africa and the Middle East; yet the pigments and painting techniques used by Roman artists are amazingly uniform. We find the same Alexandrian blue (later known as Egyptian blue), the same green earths, Almaden cinnabar (or vermilion), aragonite white, and yellow ochers in Brittany, Gaul, Romania, Scandinavia, the Near East and North Africa. Thousands of examples of

Pigments found in Roman excavations are usually automatically associated with mural paintings, such as those at Pompeii (right). They include rose-madder lake, Alexandrian blue, and cinnabar red (vermilion). However, they were also used in the manufacture of cosmetics and medicines. The coffer of a Gallo-Roman oculist, found in a late 2d-century AD tomb in Lyons, includes twenty pans of color that must have been thinned with water before use. They all contained minerals used to make pigments: white clays, hematite, goethite, azurite, malachite, white lead, and realgar, and bore identifying inscriptions as eye medicines. Without these labels, it would be easy to confuse such a coffer with an artist's paintbox.

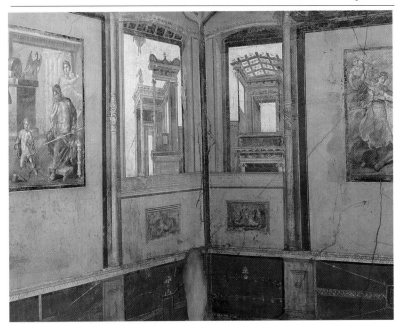

Roman-era mural paintings, decorating rooms like wall-paper, have been found across the Roman world. Most are composed of large panels with elaborate ornamental motifs: bands and stripes, leaves, architectural elements, or branched candlesticks. Figurative scenes and land-scapes, called *emblema,* are often inset within these panels.

The earliest Roman frescoes have been chemically analyzed many times, and the pigments used in them are relatively well-known. The large areas of monochrome back-ground were made with pure pigments, which lend them a vivid, saturated color. Most commonly, these were yellow ocher and red ocher (the latter either naturally occurring or made by heating yellow ocher), whites composed of calcium

Above: a wall painting in the House of the Vettii in Pompeii, c. AD 70. Rectangular painted scenes and architectural perspectives, known as *emblema,* are surrounded by a field of brilliant yellow. Other Roman houses have walls of red, white, or black. The technique used to create these decorations has been debated since their rediscovery. It was once thought that they were painted *a secco,* on a dry plaster ground with paints that had a fat-based medium similar to soap. Michel-Eugène Chevreul, a 19th-century specialist in the chemistry of animal fats, disproved that theory.

carbonates (calcite or aragonite) or clay, and carbon blacks. A few particularly rich decorations have panels painted entirely with very costly pigments, such as Alexandrian blue or cinnabar vermilion (a sulfide of mercury). The famous Villa of the Mysteries at Pompeii, whose walls have a background of dazzling Pompeii red, is one such.

The creation of violet and green colors is always interesting to note, for these colors can be made in many different ways. Roman violets are sometimes attributed to murex (a mollusk secretion that makes a true purple), but are more often obtained with an orange-hued red hematite, whose crystals are expanded by heating, which changes the color to violet. We also find violets made by mixing Alexandrian blue and red ocher. Cretan and Greek painters had created green tones by layering yellow and blue, but the Romans made green-earth pigments. This seems originally to have been an Etruscan or Gallic tradition. Green earths are rocks rich in green clay (glauconite, celadonite, chlorite). The glauconites are formed in cold-water sediments and are very abundant, especially in France. Characterized by a pale green verging on yellow, they were not highly valued by painters, relatively speaking. Glauconite greens nevertheless spread throughout the Roman Empire, from Dura-Europos in ancient Mesopotamia to as far away as Norway.

The celadonites, pale bluish greens, were, on the other hand, quite rare and highly valued by artists; the exploitable veins of celadonite could be counted on one hand. Two were particularly well-known, one in Cyprus, where celadonite was mined by the ton until the 19th century, and one in Monte Baldo, near Verona, which produced a scant yield of "Veronese earth," also known as Baldogean.

The relative paucity of the palette of colors offered by mineral pigments quite early on inspired artisans to create colors made from vegetable and animal-based dyes. This

Below: a fragment of a Roman glass vial still holds some powdered lake (dyed mineral powder). Red and rose-madder lakes have been found in Roman archaeological sites, probably made by painters or their studios. Lakes are very lightfast and were used in many ways; for example, they could be mixed with Egyptian blue to create very luminous violet compounds. They are found in the most precious wall decorations. The *emblema* usually had the most varied palette, including lead white, realgar, and pink and red lakes. Pliny and Vitruvius (a Roman architect writing in the 1st century BC) also mention the use of yellow, violet, and green lakes. Weld was clearly used for the yellow, but we have little archaeological evidence with which to identify the other two.

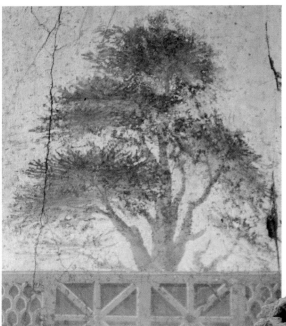

B elow: the Romans were noted for their use of green earths (terres vertes) in paintings, both for backgrounds and for the scenes themselves. Left: a naturalistic tree from Stabiae, a town near Pompeii destroyed in AD 79 by the eruption of Vesuvius. A Roman celadon green has been analyzed for chemical content. It was found in the ruins of an ancient bath complex, the thermae of the acropolis at Lero (on the island of Sainte-Marguerite, in France). It dates to c. AD 10. The painter used a mixture of Veronese celadonite, a glauconite found near Nice, and a pure Alexandrian blue, probably

entailed using a white mineral powder as the pigment base (usually clay, aluminum, or calcite), and dyeing it, as if it were a textile. Such pigments are known as lakes.

Commerce and provenance of pigments and dyes

We are fortunate to have many technical and legal texts from the ancient world that discuss pigments and dyes, for many colors were valuable commodities. What do they teach us? They specify the nature of the various pigments and dyes used, their provenances and prices, according to quality and the commercial routes along which they were traded. These products were sought as much for their medicinal properties as for their coloring abilities.

manufactured in Pozzuoli. This is a true studio recipe for green, and has also been identified in a painting from the same period found at a site in Lyons.

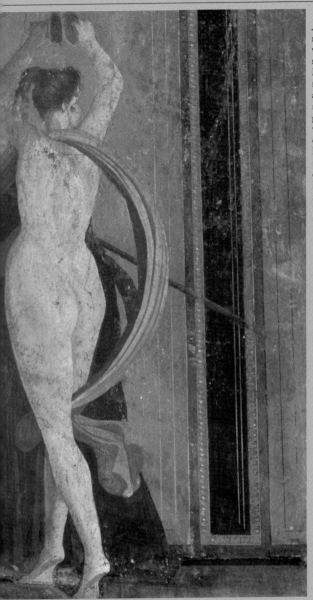

Among the most famous frescoed rooms of the Roman world are those in the so-called Villa of the Mysteries at Pompeii, remarkable for the abundant use of cinnabar red for their vivid background. This pigment was one of the most costly on the market; its lavish use in these paintings was an ostentatious display of wealth. The raw mineral was imported from Almaden, in Spain, to Rome. There, it was converted into pigment by workshops of artisans in an industrial quarter that once stood between the temples of Flora and Quirinus. In order to obtain the desired bright red, the cinnabar had to be purified, then synthesized, then ground to the correct fineness. If handled improperly, it could turn black. Vitruvius attributes this to the reaction of the pigment to moonlight. To protect it, he suggested coating the fresco in wax. Pliny the Elder gives us some contemporary prices for cinnabar: the mineral alone cost as much as Alexandrian blue—50 *sesterces* a pound, fifteen times the price of African red ocher, which was more commonly used to make red backgrounds, but has a duller, oxblood color.

The ochers were considered astringent; madder, according to the 2d-century AD Greek physician Galen, treated jaundice. Orpiment stopped hair from falling out, sanguine (hematite) was known for its hemostatic properties, and basic white lead (ceruse) was also part of the pharmacopeia. Many pigments were said to come from the Near East or Spain. For example, there are reports describing the extraction of Spanish cinnabar from Almaden and its transport under guard to Rome, where it was sold to the public.

There is also archaeological evidence of this commerce. Underwater excavations of the wreckage of a ship that sank near Marseilles in about 47 BC have uncovered amphorae containing pigments: Alexandrian blue, litharge yellow (a lead oxide), and realgar red. Many clues suggest that this coasting vessel came from Pozzuoli, near Naples. According to the 1st-century BC Roman writer

Glass was invented by the Egyptians, but in the Roman period fine glass was manufactured in Syria and Palestine. Mideastern glass was often made for export in ingots or blocks, shipped by sea to other Roman territories, and then reworked by local glassmakers. Antique blue glass was colored with a cobalt whose provenance is unknown. Below: a drinking glass, c. 70 AD, found in Italy and balls of raw Alexandrian blue glass. The white spots are quartz.

Vitruvius, it was at Pozzuoli that Vestorius, a banker friend of Cicero, established the first manufacture of blue in Italy.

Many ancient texts give us quite precise information. Even so, some provenances seem to be inaccurate, and in the end only technical analysis can bring objective data to light. Mines and lodes vary considerably; not all produce exactly the same colored mineral under the same name. When crystallized, the crystal does not always have exactly the same shape. Furthermore, the impurities associated with a given mineral differ from one site

to another. Such variables often allow us to trace the geographic origin of minerals, and this provides a first link in our knowledge of commercial exchanges in the ancient world.

In general, communities began by importing pigments, and then desired to develop local production of their own. This led to the arrival of specialized workers and the transmission of knowledge about pigment manufacture and its hands-on application, which in turn often encouraged the importation of other manufacturing technologies. The use of Egyptian blue in Roman Gaul illustrates this perfectly. After a period of importing Pozzuoli blue, Gaulish sites began, around the 2d century AD, to develop local bronze manufacture. Local painters mastered imported art techniques as well: they learned to strengthen the saturation of colors by choosing contrasting background hues; they altered the relative refraction index of the mediums in which pigments were suspended to obtain varied effects; they played on oppositions of matte and shiny by polishing certain areas of a painted surface; and they painted some surfaces with coarsely ground pigments, whose granulated texture caught the light and emphasized the brushstroke.

A Roman shipwreck found near Marseilles is noteworthy for the variety of the pigments it carried. This coasting vessel first loaded amphorae of wine near Brindes (modern-day Brindisi, in the heel of Italy) and then put into port at Pozzuoli, where it loaded pigments. It sank on the way north to Narbonensis, a port in southern Roman Gaul. Although the wreck was pillaged, its excavation yielded raw pigments and other materials used in the manufacture of colors. These included realgar (top), a sulfide of red arsenic, which may have been gathered in the Solfatara, a sulfurous volcano at Pozzuoli, on the outskirts of

Naples. Alexandrian blue (lower left) and litharge yellow, an oxide of lead, also originated at manufactories in Pozzuoli. More than 88 pounds (40 kilos) of the litharge were found. Lead oxide was shipped in the form of *tubuli*, or tubes, made by being melted and then rolled around an iron rod.

Fabric dyeing

The technique of dyeing requires knowledge that is just as specialized. The most indispensable dyes for use in textile fibers come from plants, lichens, and animals. Dyes must be extracted from their source, and then purged of waxes and resins, which must be eliminated without losing the dyeing agent. This is done through a complex series of operations in aqueous solutions—maceration (chopping), ebullition (boiling), fermentation—using controlled temperatures and acidity. Some dyes are ready for use as soon as they are rid of these impurities. Others are rendered as a "precursor," a colorless compound that must be subjected to supplementary chemical reactions to liberate the color. During the maceration of indigo leaves, for example, the colorless compound attaches itself to the textile fibers. When exposed to air, it oxidizes and the fabric becomes blue in a matter of minutes.

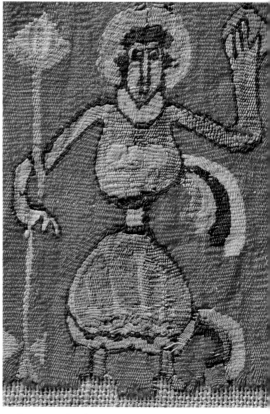

The effect is magical. The same is true for purple. To complicate matters further, fibers made of animal products (such as wool) do not take dyes in the same way as those made of vegetable matter (linen or cotton, for example). The foremost concern in proper dyeing is to fix the dye with the most solid chemical bonding possible, one that will withstand repeated washings. For this, a mordant is used. Mordant is a pretreatment of the

To dye a cloth in many colors requires a sophisticated technique. The simplest method is wax-resist dyeing, or batik. But in the classical world one most often finds polychrome textiles created with dyed yarns, as seen in this antique Coptic weaving from early medieval Egypt.

fabric in a bath of metallic salts (usually vegetable ashes, alum, tartar, iron salts, or urine), which reacts with the color. The shades and qualities obtained depend on both the dye chosen and the mordant used.

We know that Roman dyers used madder to make reds, weld for yellows, and indigo for blues. The presence of lakes (dye-based paints) in ancient artworks attests to this. Various classical authors compiled lists of plants used for medicinal and dyeing purposes, and noted the tinctorial properties of some of them. Unfortunately, archaeological evidence of both textiles and medicines remains rare.

Dyeing purple

Purple is probably the most famous color used in dyeing.

To dye a fiber is to affix the molecules of the dyes as solidly as possible to its surface. The chemical reaction (chemical absorption) varies, depending on each pairing of dye and fiber. In antiquity, fibers belonged to two categories: those of animal origin, with a protein base (wool, silk, leather, and parchment); and those of vegetable origin, with a cellulose base (hemp, linen, cotton,

The Roman emperors alone had the right to wear clothes dyed purple, which was sometimes known as antique or imperial, and was associated with supreme power in cultures from Israel to Persia. The texts tell us of its irresistible attraction among the upper echelons of society and of the emperors' relentless refusal to allow others to use it. Nero went so far as to punish offenders with death.

Purple was remarkable for both its costliness and its beauty. Vitruvius tells us that it "is the most precious and the most pleasing to the eye," and that it comes from Mediterranean mollusks of the murex family. It takes

papyrus, paper). Fibers are still often dyed using natural methods, yielding beautiful, subtle colors. Above left: yarn dyeing in Cappadocia, in Turkey; above right: cloth dyed with indigo in Cameroon. Indigo dyeing is characterized by direct fixation, without the intermediary use of mordant on the fibers.

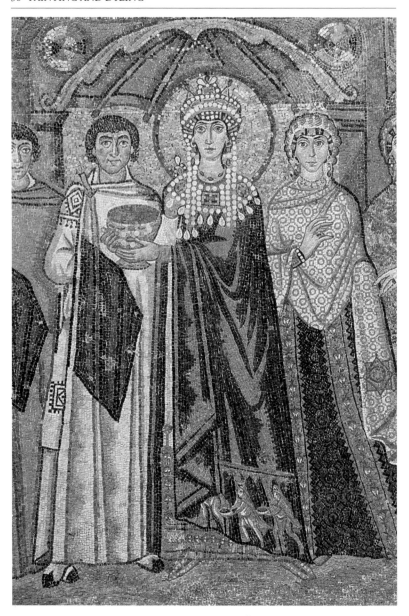

nearly 10,000 mollusks to make a gram of dye. Ancient beds of shells have been found in the sea at Tyre and Sidon, and in enormous quantities at Tarentum in southern Italy, bearing witness to the existence of this craft in those cities.

Today we have reconstructed the complete process by which murex shells were made to produce purple dye. The coloring molecules are similar to those of indigo. The dyes varied with different types of mollusks. This is noted by Pliny, who remarks that the northern Mediterranean murex gives a different color from that of the south. Dye baths were also manipulated to alter the color. Sometimes two baths were used, each with a purple from a different source, but this was expensive. Later, murex was replaced in the second bath with less expensive kermes or indigo.

With the fall of the Roman Empire, much of this technical knowledge was lost. We do note, however, that the taste for colorful mural paintings survived. Some extant Carolingian and Romanesque frescoes demonstrate the survival of the use of sandy ochers, ochers, green earths, and even Egyptian blue. Nevertheless, the reappearance of very bright colors during the Middle Ages was a dramatic event.

In ancient Rome, only the imperial family could wear purple. This practice continued after the empire became Christianized in the 4th century. An echo of it remains in the use of deep red for high liturgical dress in some Catholic traditions. In the Italo-Byzantine church of San Vitale in Ravenna, near Venice, a mosaic (c. AD 545) represents the Empress Theodora (opposite) wearing purple robes and surrounded by members of her court. Only the highest dignitaries had the right to wear a band of purple on their white robes. The tesserae (mosaic tiles) in Byzantine mosaics were mainly glass colored by metallic oxides, with some natural marbles, and uncolored gilded glass tesserae, made by fusing gold leaf between two layers of clear glass.

Murex ocenebra erinacea, common throughout the Mediterranean, is one of many mollusks in the murex family.

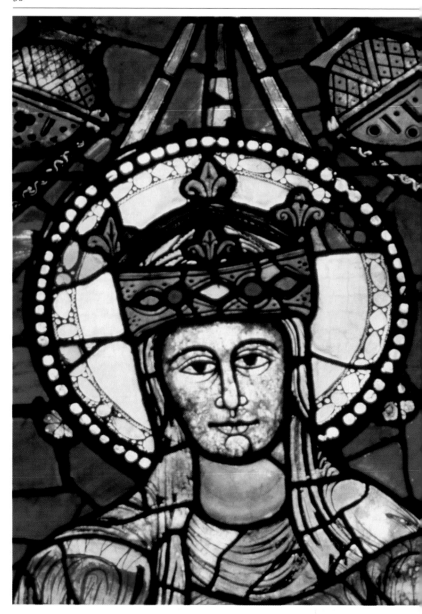

The palette of colors broadened considerably in the Middle Ages. In addition to the materials inherited from antiquity, many new pigments and dyes were created, better adapted to the new supports used in painting and other art forms. The great international textile industry of medieval Europe was largely responsible for stimulating the quest for new colors.

CHAPTER 2

COLORS IN THE MIDDLE AGES

Brightly colored fabrics were a luxury in the Middle Ages. Rich merchants imported cloth and dyes destined for the royal and princely courts. Clothes and ornaments meant for display often bore the heraldic colors of their owners: Persian or azure blue, emerald green, saffron yellow, scarlet, purple, or black. Left: a detail from the famous, brilliantly colored stained-glass window called *Notre Dame de la Belle Verrière* (c. 1170) in Chartres Cathedral. Right: textile merchants study samples in a detail from a French 15th-century illuminated manuscript.

New colorants

In painting, new products derived from the three realms—animal, vegetable, and mineral—appeared and were substituted for the colors of antiquity. Blue made from lapis lazuli, imported at great cost from the East, replaced Egyptian and Alexandrian blue. The plant extracts folium violet and rose-madder lake replaced the purple of antiquity, which had become impossible to find. Green derived from copper resinate supplanted malachite and chrysocolla greens. And the dangerous yellow made from orpiment (arsenic) gave way to tin and lead yellows. The evolution of colors is linked to that of supports: little by little, parchment (made from skins) and paper (made from rag pulp) replaced papyrus, while linen canvas came into use with easel painting. At the same time, new oil- and tempera-based binders were developed.

As for dyes, their evolution reflects both technical and economic changes. For the most part, the dyes themselves remained the same as those used in antiquity, but procedures continued to improve, allowing for the dyeing of all types of materials as well as the creation of ever brighter colors. The textile industry became the backbone

Parchment is a supple, resistant support for writing and painting. It takes colors very differently from a plaster wall or wood panel or sarcophagus case, but it is a costly material. Parchment sheets gathered together between bound boards form books or codices and could be decorated in a variety of ways. Above: a detail from the rare and precious 8th-century Irish illuminated *Book of Kells*. Such books were painstakingly assembled over many years by numerous copyists and illuminators.

of the economy throughout Europe. Luxurious and sturdy textiles once available only as expensive imports from the East began to be manufactured locally. These included wools and, later, silks, linens, and other stuffs. A vogue for colored fabrics arose in the 12th century, and has continued ever since. Clothing, embroidery, and tapestry all acquired colors, continuously feeding the demand for dyes.

As the textile industry developed, there grew along with it a more sophisticated system of color classification. The attributes and value of any given dye were determined by the political, economic, and social context. While colors were still divided into bright and dull, red lost importance as the value of blue increased. Using their new palette of colors, painters and dyers told the story of these different mutations.

The art of dyeing

Dyeing had always depended to a great degree on vegetable sources. Curiously, almost any shade of color could be produced from plants except green. But aside from the bright red of madder and the brownish yellows of the tannins, vegetable colors were not very light- or waterfast, and faded quickly. Despite the brightly colored dress of figures in medieval manuscript illuminations, most people formed a rather dull crowd. Their clothing was the undyed natural grayish brown of hemp, wool, and linen, or was dyed in muted tones

Below: detail from a colorful medieval illumination. Orpiment, an arsenic-based pigment, was much prized by the illuminators. When it was coarsely ground, its prismatic crystals were spread out in thin layers across the surface of the painting, reflecting a lot of light and creating very luminous yellows. Mixed with blue, it produced a dull green. Artists often placed green next to its complementary color, red, to reinforce the latter's brilliance by contrast.

with plants from woods and heaths: mulberry and huckleberry for the blues; sea or land lichen for the mauves; weld, broom (genista), and berberis for the yellows; wild madder, patience dock, and alkanet for the reds; walnut and chestnut bark for browns; sumac and gall nut for the blacks. Moreover, these dyes were quite unstable, since they were fixed with ineffective, inexpensive mordants, usually vegetable ashes, fermented urine, or vinegar.

Thus, there was a marked difference in the quality of the colors sought by the wealthy, which were bright

and colorfast. The quality of the dye could increase the price of a cloth tenfold. Hence the importance of the dyer's profession.

Greater and lesser dyeworks

The dyers were grouped like other artisanal trades into regulated guilds or corporations, often under the

It is extremely difficult to analyze the chemical composition of the dyes used on medieval fabrics. The percentage of dye present in a textile fiber is small, and thus the amount available for analysis is minute. In general, the composition of natural dyes varies according to place of origin, procedures used for extraction, and method of application. Furthermore, dyes are not always stable or color-fast, and may fade or turn over time. Yellows are especially fragile, and a textile that appears blue today may originally have been green. Left: a medieval scene of dyers at work.

patronage of a saint (the French patron was Saint Maurice; the Venetian dyers had Saint Onofrio). In most cities with a textile industry, there were two categories of dyers in separate guilds, usually called the greater and lesser arts. The first group of artisans made luxury products of superior quality, using only the best fabrics and colorfast dyes, such as madder, indigo, weld, cochineal, and kermes. Often, this was subdivided into smaller groups according to the dyestuffs to which a group of artisans had the rights: the dyers of red were also in charge of yellow; the dyers of blue could also take charge of greens and blacks.

The lesser dyeworks shared the rest of the clientele, less prosperous but far larger, and provided them with fabrics dyed with poorer, less stable dyes. As the textile industry grew, fashions evolved, as did the system of warehousing, and conflicts frequently arose among the guilds. The regulation by city or court administrators thus specified down to the most minute detail the nature of the dyes and mordants authorized or forbidden to each group of dyers. They also organized the use of watercourses in such a way that each guild could make use of clean water in turn, to rinse fabrics before and after dyeing.

Since antiquity, authors have compiled technical manuals on dyeing and pigment manufacture. These record the known or supposed properties of minerals (earths, rocks, and metals), vegetables (wild and cultivated plants), and animals (both real and imaginary), often with careful descriptions of each source material's shape, dimensions, color, environment, and applications. The 1st-century AD *Natural History* of Pliny the Elder, for example, lists the colors used in painting and metallurgical procedures for pigment extraction. Pliny also describes plants used for dyeing and medicine, including dried safflower blossoms (above left) and buckthorn berries (below left), used to make yellow and red dyes, respectively. Encyclopedic texts also played an important role in the Middle Ages. The most famous were written by Isidore of Seville (c. 560–636), Rabanus Maurus (c. 780–856), Hugh of St. Victor (1096–1141), Vincent of Beauvais (c. 1190–1264), and Roger Bacon (c. 1220–92). Often these authors anthologized more ancient texts, and have thus preserved many antique recipes for pigments and dyes.

Madder

The use of vivid dyes was the prerogative of the wealthy, for the higher quality dyes and mordants were still often imported and extremely expensive. But the madder plant (*Rubia tinctoria*) was to be found locally in many parts of Europe, and was especially cultivated in Normandy, Languedoc, Provence, Spain, Sicily, and Lombardy. Its

A bove: an illustration of the madder plant from a 1642 commentary on *De materia medica* (*On Medical Matters*), a 1st-century AD text by the Greek physician Dioscorides, principal authority on botany and medicine for 1,500 years. Madder dye is made from the root of the plant (left, in dried form) and was most often used to dye wool red. Like most dyes, it had medicinal virtues as well. According to Dioscorides, "There is a wild madder that grows by itself; and there is also one that can be cultivated, and it is very advantageous to sow and cultivate this plant. Its root is slender, long, and red. It stimulates urine, and for this reason is very beneficial for jaundice, sciatica, and paralysis, taken as a beverage steeped in honeyed water. Steeped in vinegar, it removes white spots on the skin."

root contains many red and yellow dyes. Dried and milled, it yields a paste or a powder, the form in which it is sold. Mordanted with alum, madder produces a bright red color much valued in the Middle Ages for the dyeing of festive clothes, wedding clothes in particular. Thus, the bright red of the upper classes was also available to common people.

Woad blue

Woad (*Isatis tinctoria*) is another dye plant cultivated since the 10th century in Europe, notably in Thuringia, Alsace, and Normandy. It is the base of blues. But woad is a cruciferous plant, whose cultivation dramatically impoverishes the soil; the popularity of blue dye thus threatened to starve entire populations. The process for

making woad dye was fairly elaborate: the leaves and stems were washed, dried, and stored in balls or compacted lumps, then mill-ground. The resulting powder was made into a paste and fermented, which liberated a precursor of the dye. This substance, concentrated woad extract, was black and granular, and was called pastel. But it could only produce a washed-out blue, and was used for work clothes.

At the close of the 12th century, however, a technique was found for making brighter blues from woad, drawing the attention of the luxury textile market. Dyers who used it on wool and silk were able to produce a very

Below: dyers tint red cloth in a 1482 illumination. Cloth dyed with madder was first soaked in a mordanting bath, in a solution of alum and cream of tartar, then in a heated dye bath containing powdered madder. A period text notes: "Ordinary reds were dyed with pure madder, without mixing in brazilwood, or any other ingredients."

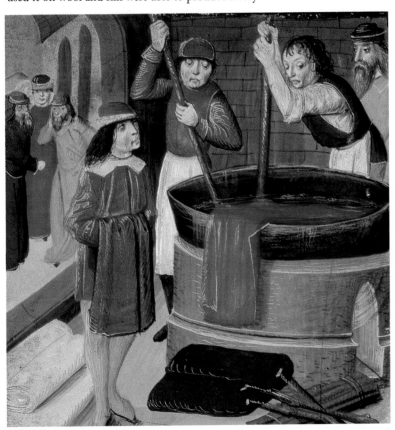

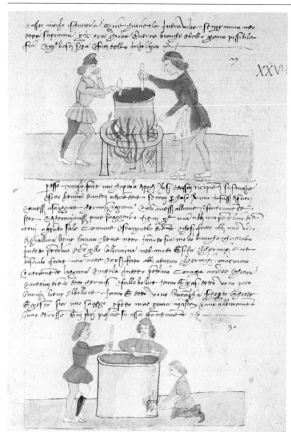

XXVI

Left: miniatures from a 15th-century Italian recipe book for silk dyeing show workers heating red dye more than blue. Indigo dyeing was done at a lower temperature than madder, in vats maintained at 104°F (40°C). Dyes and extracts are fragile, and must be stored properly or they will spoil. Exposure to light and oxygen will cause most dyestuffs to deteriorate, and few keep well in liquid solution. Below: pastel leaves are dried and compacted into a ball for storage and shipping—the traditional method for preserving the precious woad blue of Languedoc.

stable, high-quality, lightfast color. At this time, cultivation of the woad plant shifted from the once-fertile fields of northern France to Languedoc, where it created the proverbial wealth of the region around Toulouse. As the quality of blue improved, taste for the color red lessened, and a new sensitivity to colors and their attributes began to accord a privileged position to blue. It was at this time that the mantle of the Virgin became blue in paintings. The robes of the king of France, which were traditionally red, also changed to blue. The

madder merchants tried in vain to reverse this tendency. In the 13th-century churches of Thuringia, the devils who populate the stained-glass windows and mural paintings are blue, not red or black, as in earlier iconographic traditions. The success of the woad or pastel blues went in tandem with the increasing success of the European textile industry. Woad was the speciality of Toulouse, whose fine houses bear witness to this day to the prosperity brought by the color blue. In the 14th century, as the commerce in fabrics was reorganized on a large scale, compacted balls of woad were exported from there throughout Europe.

Important steps toward enriching the palette

Despite improvements in the use of local dye plants, in the Middle Ages most pigments and dyes were still imported from the Indies, the Sunda Isles (Malay archipelago), and Ceylon (Sri Lanka): cochineal, extracts of brazilwood (a redwood, sometimes called bresil, imported from the island of Ceylon and later from South America), Persian berries or Indian saffron for yellows, indigo or lapis lazuli for blues. For centuries, these wares were carried west by Arab merchants who bought them in India and transported them first by sea to Hormuz, in Persia, then by a long chain of caravans to the Levantine commercial ports of the Mediterranean: from Baghdad to Alexandria, Cyprus, or Rhodes. There, they were sold to merchants from the four great Italian maritime republics, Amalfi, Pisa, Genoa, and Venice, who carried them west and north to Europe.

Indicum, or indigo blue, was one of the principal imported materials. The concentrated color extracted from the indigo plant (*Indigofera tinctoria*) was transported in pans or squares made of compacted powder. The coloring agent yielded by the extract produced indigotin, blue tint, and indirubin, red tint. The dye produced from these was more or less purple, depending on the provenance. A record of 1228 notes that Marseilles imported one of the most renowned Levantine indigos, that from Baghdad. This commerce grew at a steady pace.

More than three hundred different *indigofera* plants have been identified, yielding indigos from Africa, Asia, and America. The oldest and most highly regarded was from Bengal. Below: a chunk of indigo from Benares. Since the dye was expensive, each vat was used more than once, first to dye the strong colors, and then to make paler fabrics.

In antiquity indigo was imported as indicum in flat, dried bricks, and Roman writers such as Pliny did not know that it was made from a plant. He described it in the *Natural History* as "a certain silt that forms in frothy water and attaches itself to reeds. This color seems to be black when ground, and yet when diluted it makes a certain very rich purplish blue."

Another essential import was alum, a sulfate of aluminum and potassium mined from rocks and found in rare sites along the Mediterranean periphery. The best and most universally used mordant, it was indispensable to the textile industry. The Genoese mined and purified it through a process of successive crystallizations. The Aegean island of Chios served as the Genoese warehouse and distribution center for alum and was the republic's main base of commerce in the Mediterranean. The Chios alum industry was run as a monopoly by one of the most powerful financial institutions of the time, a state-guaranteed finance association called the Maona, which fixed prices and controlled the amount of alum to release. Alum from Chios was exported to the great wool centers: Venice, Florence, Southampton, and especially Bruges, whose markets exported it to all others.

Pigments used in painting

Medieval painters mostly used mineral pigments, either imported or, more often, made locally. Principal colors were blues made of lapis lazuli or azurite, copper and earth greens, ocher and orpiment yellows, minium and vermilion reds, red and black ochers, and lead white. In addition, they also used the same coloring agents used in dyes as paints, in the form of colored lakes. To make lakes, the tinctorial extract was affixed to mineral substances, which made the colors insoluble. Hence cochineal reds were used to make kermes lake, for example, and brazil was used to make both a dye and the red paint called brazil or columbine lake; the same Persian berries were used in yellow dye and a yellow lake, as were indigo blues and various red and rose madders.

The range of available colors grew larger between the 9th and 15th centuries, and engendered important changes in both dyeing and painting techniques. Certain colors inherited from antiquity were replaced with new pigments or dyes that were easier to find. A red-violet called folium, made from French tornsole, replaced the hard-to-find Tyrian purple. Whites

Few examples of medieval dyes or paints have been preserved, perhaps because the materials were so valuable that all were used, or perhaps because they were so perishable. Rarely do traces remain of the tools or paints used in a monastic scriptorium or dyer's shop. Archaeologists working in the garden of the Bishop's Palace at Avignon, France, found a clam shell, used as a painter's dish, and still containing pigments. Below: a similar shell, containing a rose pigment, a mixture of vermilion red and chalk white, was found in the ruins of the medieval French castle of Mehun-sur-Yèvre. Right: in a 15th-century miniature, an artist works on a panel painting while an assistant grinds pigments. Visible on a table are a set of brushes and several clam shells holding paints.

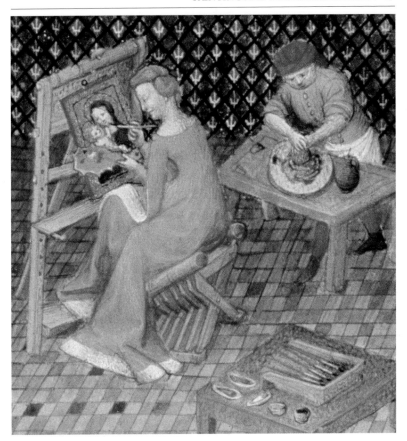

made from eggshells or calcinated bird bones supplanted those made from earth from Selinus in Sicily or chalk from Eretria. Mountain blue (azurite) and lapis lazuli replaced Alexandrian (or Egyptian) and Pozzuoli blue, which had become practically impossible to find; woad blues from Normandy, England, and Germany were substituted for the rare indigo blue imported from Bengal.

Book illuminations

Protected from light and dirt within closed manuscripts and bound volumes, painted illuminations—medieval

The preparation of colors was a long and exacting procedure that required extensive knowledge on the part of the painter. Pigments were ground on marble, either dry or mixed with water. The blacks, which have a strong tendency to clump, were the most time-consuming to prepare.

illustrations—are generally very well-preserved. They make up a unique collection of precious artworks that spans a thousand years. Manuscripts thus bear witness over a long period of time to the evolution of tastes, as well as to the technical and economic changes that affected them.

It is no surprise that illumination played an important role in the history of pigments. Illuminations often served as models for many other art forms, from fresco and panel painting to stained glass, tapestry weaving, and polychrome sculpture. In the 12th century, a monk named Theophilus (probably a German Benedictine whose real name was Roger of Helmarshausen), himself an artist, wrote a treatise on techniques of painting,

The famous set of 15th-century tapestries known as *The Lady and the Unicorn* depicts the five senses allegorically. Sight, represented here by the lady holding a mirror, is the noblest sense, along with hearing, and is placed in the center hanging. Brightly colored, intricately woven tapestries such as these were a luxury item, and used a rich range of colors to delight the eye.

mosaics, goldsmithy, and other crafts, entitled *De diversis artibus*, or *On Divers Arts*. This text is a mine of interesting advice and information. Among other things, it explains how to paint on parchment using azure, vermilion, copper green, and lead white; how to write with gold ink; and how to paint red altars, horse saddles, wall hangings, faces and eyes, and the hair of adolescents or old men.

A 9th-century palette analyzed

Most medieval manuscript illuminations were painted in workshops in abbeys and monasteries, which obtained their colors from a variety of sources. We know from archival documents that as early as the 9th century brazilwood and indigo were imported into Europe for use in making reds and blues. The monks of the abbey of Corbie, near Amiens, France, bought indigo at the market in Cambrai. In AD 716, they were granted a royal charter to go to Fos, near Marseilles, to acquire orpiment for the monastery's scriptorium and spices for its infirmary. They also brought back papyrus and skins for rich leathercraft.

A manuscript titled *De laudibus sanctae crucis* (*In Praise of the Holy Cross*) was written out and illuminated in the mid-9th century at the abbey of Fulda, one of the most important scriptoria in Germany. Its paints and inks have been analyzed chemically, so that we now know that the blues were derived from indigo and lapis lazuli, green from copper resinate, yellow from orpiment, orange-red from lead minium, dark red from hematite, purple-red from folium, and white from lead (ceruse). The bronze color was created with powdered brass.

Chemical analysis aids us in understanding the techniques and methods of the illuminator. For example, to lighten a color he mixed in lead white; he used colored glazes to create effects of transparency; he avoided

Gold was used to ornament paintings, manuscripts, and sculptures. But it was not merely a yellow color; valued for its untarnishable brilliance, it represented the union of all colors and the presence of light itself, and was associated with the sun, with deity, and with supreme beauty. Gold was added to artworks in many forms: as an ink, a thin leaf, or an amalgam used in gilding. Most often, it was applied in a thin layer, and buffed to a shine with a polished agate or wolf's tooth. Below: an ivory sculpture with gilded details, c. 1260–80.

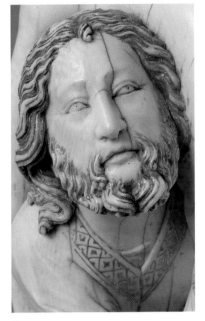

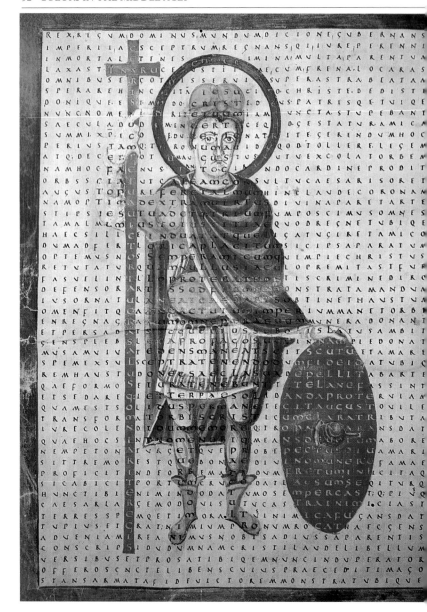

copper greens, which were unstable, sometimes tainting neighboring colors or even damaging the parchment support. He was aware that orpiment (arsenic trisulfide) was toxic, although this danger was offset by the intensity of its color. In general, yellows and greens were the weak points in his palette.

We have some collections of medieval pigment recipes, and though they are difficult to read, they support the modern chemical analyses. Recipes were carefully researched, with the aim of enhancing the characteristics of each color and minimizing its defects, and some mixtures were permitted, while others were discouraged. For example, pine resin and bitumen were added to copper greens to stabilize them. Orpiment was not to be mixed with any color, but vermilion could be mixed with madder lake or dragon's-blood red. Colors made from copper tended to bleed on the page and damage other paints, and techniques were devised for controlling this. Such pigments could be separated by a band of another color that prevented the copper from spreading. Another method was to separate colors in layers: for example, vermilion red might be covered with a madder glaze that had gum arabic in it, which acted as a sealant and prevented bleeding. At the same time, the use of layers and glazes allowed the artist to play with the brilliance and transparency of the final colors. Throughout the Middle Ages, blue made from the precious stone called lapis lazuli was the most prized of colors. Neither azurite nor indigo could rival it, although they were more ancient. The process of extracting the precious blue powder from the raw rock was long and arduous, and involved mixing the ground stone in a preparation made of Venice turpentine, resin, oil, and wax, which drew out impurities. We do not know the origin of this procedure, but there are countless variants of it in the old recipe books.

Attempts to re-create colors from these antique recipes have not always been successful; often we are hampered by gaps in our information. Some minerals and plants are difficult to recognize by their medieval names. Others, such as the French tornsole, which produced a red-violet extract, have disappeared. The

Color has always been intimately bound to writing. All over the ancient world, engraved and painted inscriptions, often polychrome, may be found on temple walls and funeral stelae. The relationship between text and image reached a pinnacle of integration in medieval manuscript illumination. Opposite: the manuscript known as *De laudibus sanctae crucis* (*In Praise of the Holy Cross*) displays some of the complexities possible. It was composed in the early 9th century by Rabanus Maurus, abbot of the German monastery of Fulda. The text is in calligrams, a sort of puzzle or visual code.

Overleaf: this illustration from a 14th-century manuscript on the medicinal virtues of plants, animal products, and minerals, depicts shelves of substances known for their therapeutic properties as well as for their uses in painting. Among other items we note two blue pigments, lazurite, or lapis lazuli (labeled "la pierre de lazur"), and Armenium stone, or azurite; a red pigment, hematite; a white pigment, basic white lead (the sack labeled "ceruse"); a black pigment called lapis demonis; and dragantum, or green vitriol. Also depicted are squid (which produces an inky substance), vinegar, mastic, and other drugs.

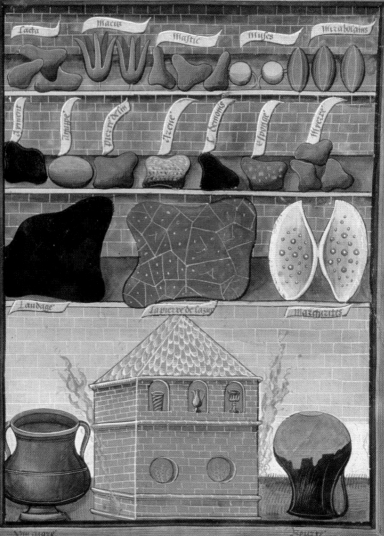

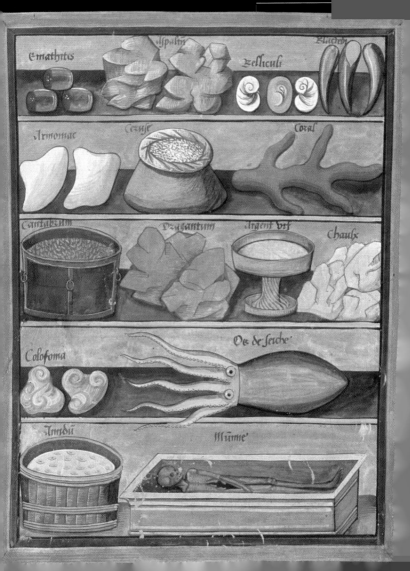

Emathtis Aspalti Blacheby

Belliculi

Armoniac Ceruse Coral

Cantabrum Dragantum Argent vif Chaulx

Colofoma Os de seiche

Amdu Mumie

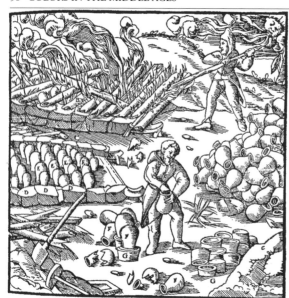

authors of the old technical treatises were for the most part literary writers, rather than experienced makers of paints and dyes, and did not always transcribe the recipes fully or clearly.

The contribution of the alchemists

In the Middle Ages, much of the research in chemistry and the technology of pigments was carried out by physicians and alchemists, whose laboratories and methods were often secretive and described in an arcane language, laden with metaphors. Colors themselves had symbolic value for the alchemists, who wrote of their activities in mysterious terms as the "white, black, yellow, and red operations." These early chemists made some major discoveries, though they published them only reluctantly, and in the cryptic terminology of a religion. They perfected various techniques of heating: in a closed oven, or athanor, a water bath (the wet method), or a hot-sand bath (the dry method). They studied the processes of extraction and distillation of solids and liquids, and experimented with new products, such as

Opposite: a 16th-century recipe for making fine-grained scarlet lake.

"As for minium [red vermilion], used for painting, both Dioscorides and Vitruvius note that it is cooked in an oven after it is washed."
Georgius Agricola (1494–1555), German historian and mineralogist, *Dialogue on Mining*, 1530

Left: an illustration of the manufacture of vermilion from a 1561 edition of Agricola.

"The manner used to extract and prepare minium is quite unusual. It is drawn from the earth in masses,... The lode of this material, enveloped in a red powder, is the color of somewhat rusty iron. When extracted, the blows of the pickaxe cause many drops of quicksilver [mercury] to come out, which the workers try to collect. When the masses are gathered together in the workshop, they are thrown in an oven to dry them out, for they are very moist... When the masses are dried, they are piled up and ground with iron pounders; by means of washings and decoctions, all foreign matter is eliminated and the color appears."
Vitruvius, *De architectura*, Book VII, 1st century BC

¶ Pour faire lacca de graine fine.

PREN vne liure de tondure d'écarlate fine, & la mets en vne poelle neuue pleine de laiſſiue, qui ne ſoit point trop forte : puis la fay boüillir tant que la laiſſiue en prenne la couleur. Ce fait, pren vn ſachet, large par en haut, & agu par en bas, au-quel verſeras la-dite tondure d'écarlate, & la laiſſiue, mettant vn vaiſſeau deſſous: puis preſſe bien le ſachet, tellement que toute la ſuſtance, & toute la couleur en puiſſe decouler: apres laue la tondure, & le ſac, au-dit vaiſſeau, où eſt la couleur. Et ſil te ſemble que la tondure ait encore d'auantage de couleur, tu la feras boüillir auec autre laiſſiue, faiſant comme par-auant. Ce fait, mettras chauſer au feu la-dite laiſſiue coulourée, mais ne la laiſſe point boüillir: & faut tenir toute preſte, ſus le feu, quelque poelle nette, auec de l'eau nette, la-quelle, eſtant chaude, y mettras cinq onces d'alun de roche pulueriſé: Et incontinent que tu le verras diſſoudre, pren vn ſachet, comme le premier: & quand la couleur ſera chaude, ôte-la du feu, & y boute le-dit alun : puis jette ainſi tout enſemble au ſac, mettant deſſous quelque vaiſſeau plommé: & regarde ſi par en bas la couleur en vient rouge, lors prendras de l'eau chaude, & la verſeras au ſac, y verſant auſſi tout ce qui eſtoit coulé, au-dit vaiſſeau, ſous le ſac : & verſe tant de fois ce qui coulera par en bas, que tu verras que la liqueur qui en ſorte, ne ſoit plus rouge, mais claire comme laiſſiue: ayant ainſi écoulé toute l'eau, la couleur demourera au ſac, la-quelle tu deferas d'vne ſpatule de bois, la mettant au fond du ſac, & la reduis toute en vne maſſe, ou en tablettes, ou comme bon te ſemblera: puis la mets ſaicher, ſus vn carreau neuf & net, à l'ombre, ou à l'air, & non pas au ſoleil. Et par-ainſi tu auras vne choſe excellente.

The extraction of coloring matter from a plant or insect may require several successive operations. These often resemble the processes of alchemy: maceration, decoction, distillation, decantation, precipitation, filtration, washing, and drying. The alembics and water baths used by doctors and the athanors of the alchemists were also used in the preparation of colors. Above: alchemical distillation, using alembic and athanor, in a 1642 illustration. Below: purified color extracts such as this cochineal carmine were sold as nuggets, or troches.

mineral acids; chloride (hydrochloric acid); oil of vitriol (sulfuric acid); and aqua regia, or alcohol (aqua vitae). These inventions were to play a major role in the later development of chemistry—in particular physical chemistry. Because of their interest in the mutable properties of metals, the alchemists also stimulated a renaissance in the production of colors: they made vermilion from sulfur and mercury; orpiment yellow by mixing sulfur with arsenic; golden yellow, called mosaic gold, by marrying sulfur, tin, and mercury.

At this time

painters were also employing a green, translucent and luminous, made from a copper resinate obtained from a mixture of copper acetate, turpentine, and bitumen, that was far superior to malachite green, which is a copper carbonate, related to azurite. Malachite green is muddy and not stable.

Yellow long remained a problem. The only source for a true yellow was orpiment, a rare mineral, and dangerous to handle, whether produced naturally or synthetically. Lakes made from plants such as weld also existed, but were not lightfast. But at the beginning of the 14th century a new yellow made its appearance in northern Europe, derived from tin, known in Flanders as masticote. This was a lead tin oxide with the bright yellow color of orpiment, but chemically neutral with regard to other pigments (some lead-based paints turn other colors gray), and only mildly toxic. Although it was difficult to produce, it has been identified in painting and illumination from the 15th century on. It was sometimes mixed with a lapis-lazuli blue to make green.

The 15th-century palette

The palette of colors in the 15th century was characterized as much by a refinement of

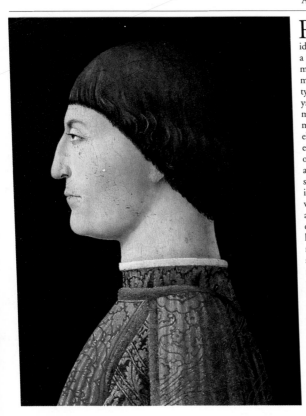

Researchers and art restorers routinely identify the pigments in a painting. The operation must be conducted on microscopic samples; typically, chemical analysis and an electron microscope are used to measure the chemical elements (iron, sulfur, etc.) present in the layers of paint. Such analyses are imprecise, however, since they cannot always identify the molecules with which these elements are bonded. Furthermore, old archival documents have sometimes been misinterpreted, leading scholars astray. The misidentification of the yellow used by painters in the 15th century is a case in point. Reliable analyses had detected lead in the various yellows. Contemporary recipes indicated the use of a yellow pigment called masticote, once thought to be a lead oxide, until the day when an X-ray diffraction identified the yellow in paintings as a tin oxide. Left: a 1450 portrait of Sigismondo Malatesta by Piero della Francesca. Opposite: a detail of the painting and, below it, an enlargement magnified 400 times under a microscope.

painting and dyeing techniques as by the introduction of new pigments and dyes. In painting, the invention of optical and atmospheric perspective led to more experimental uses of color. Indeed, atmospheric perspective, as practiced by the painters of Flanders and northern Europe, depended on the artist's control of the palette. An illusion of recession into depth was achieved in landscapes by the use of monochrome blue tones in the background, and by making the sky a paler blue as it approached the horizon. Renaissance artists manipulated color to create a sense of volume, depth, and distance; light and shadow, which played an increasingly important role, were expressed through

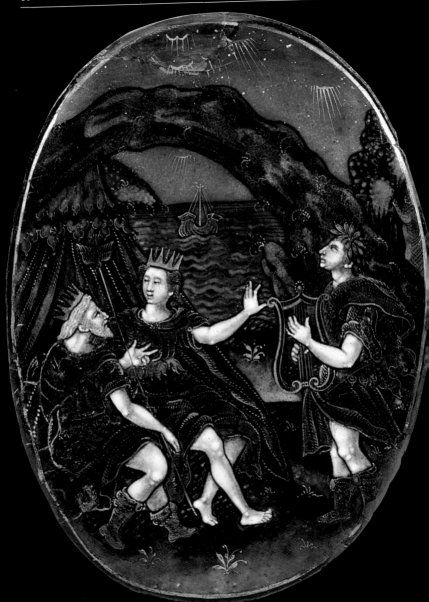

Enamelwork

Enamel is made from an opaque colored glass that is baked onto a metal surface, usually copper. The glass is a fused mixture of silica and an alkaline flux of sodium or potassium. Colors are created by adding metallic oxides: copper oxide for green and light blue; cobalt oxide for deep blue; oxides of antimony and tin for yellows; iron or copper oxides for reds; tin oxide for white. Medieval metalwork inherited techniques from the Romans. The ornate enamels of Limoges, which flourished from the 12th century through the Renaissance, used a sodium-based flux similar to that of ancient Roman glass. In fact, some scholars have thought that medieval artists melted down actual Roman colored-glass tesserae—the small cubes of glass used in mosaics. Colored glass was ground to a powder and poured into shallow hollows engraved in a copper plaque (for champlevé enamel), or in spaces separated by a thin metal wire (for cloisonné enamel). The plaque was then fired at about 1652°F (900°C), and the enamel fused and became hard. It was then polished to bring out the luster of the colors. Far left: a 16th-century painted glass-enamel plaque by Léonard Limosin; near left: two late 12th-century champlevé enamels from Limoges.

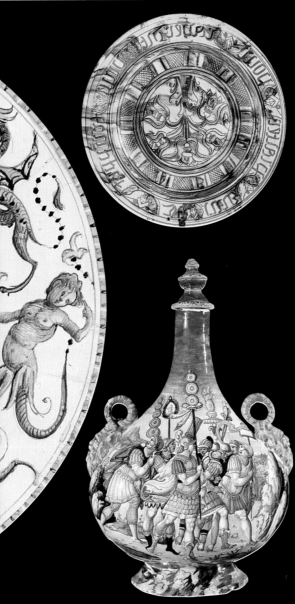

Glazed ceramics

Terracotta ceramics are painted using colored glass powder in a liquid solution. In this state, most glazes do not show the colors they will have after firing. The ceramic painter thus can only imagine what the final image will look like. For example, cobalt looks black but when fired turns a deep blue; manganese oxide also looks black but turns violet; rose powder with a lead-oxide and antimony base becomes a fine bright yellow. The art of glazed ceramics reached a high level in the Middle Ages, when artists learned to control the heat of their kilns and the purity of their glazes. White, red, and bright pink remained difficult colors to make. Copper-based green was bright but capricious, with a tendency to migrate and spread over the design (as we see on the 16th-century Beauvais plate at near left, above). Several Italian towns became centers of fine painted ceramics in the 16th century; at Faenza and Urbino, painters became masters of color, playing with yellow, orange, and blue grounds set against a glaze of remarkable whiteness. Far left: a plate from Urbino, c. 1579; near left, below: an Urbino jug, c. 1540–50.

shifts of hue as well as tonality. Artists began to use the trick of placing contrasting colors together to create optical vibrations. Thus, cross-hatchings in gold or violet lines made reds and greens vibrate. Grisaille (a gray tone), made with colloidal silver, was used to represent the metallic sheen of armor or windows.

The luxurious illuminations of the prayer book called *The Boucicaut Hours,* probably painted in Paris c. 1407, offers an interesting case study. The anonymous artist, known as the Boucicaut Master, worked in the meticulous workshop style of the Van Eyck brothers. He used varied and high-quality pigments, including no less than three different lapis blues, created by ever finer grindings of the pigment, as well as an indigo blue. Working in a very small format, he took extraordinary care in the shading of colors to represent the play of light and shadow. He applied organic lakes to increase the number of shades; in flames, for example, red lake from brazilwood was laid over vermilion to create a bright effect; a columbine lake was layered over lapis-lazuli blue to achieve red-violet. Gold leaf was used decoratively, as it often was in illuminations, but was also modified in places by being deliberately coated with translucent brazilwood red or copper-resinate green; and some silver surfaces were shaded with translucent yellow or green lake.

Around 1456, the Florentine painter Antonio del Chierico illustrated a copy of the *Geography* of Strabo, an ancient Greek author. He used a copper resinate for green, kermes lake for pink, and two superimposed blues, lapis and azurite. The simultaneous use of superimposed lapis and azurite blues is noteworthy as an early example of a technique that came into general use in the Italian Renaissance.

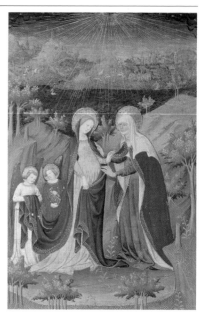

The luxurious manuscripts created in the 15th century for princes and other wealthy art lovers were often decorated with paintings by great masters, who vied to enrich them with brilliant colors. Above: a scene from the early 15th-century *Heures du maréchal de Boucicaut* (*Book of Hours of Marshal Boucicaut*). Right: two details from the book show the use of gold leaf.

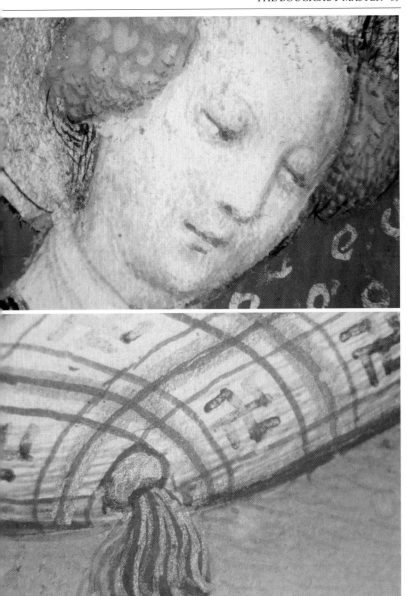

The rise in the standard of living in Europe in the 16th century stimulated demand for coloring agents, which in turn encouraged trade. Many governments attempted to control the sources of imported dyestuffs. The scientific revolution of the 17th and 18th centuries led to the development of synthetic pigments and dyes, and the range of colors available for textiles, paints, and other uses greatly increased.

CHAPTER 3

THE EXPLOSION OF SUPPLY AND DEMAND

Left: a 1756 box of samples of pan indigo from India, Java, and Guatemala. Right: the Sèvres porcelain factory in France developed color wheels, an early form of standardized color coding.

In the age of exploration, dyes and colorants were a precious commodity, as valuable as spices or silk. The traditional trade and shipping routes were disrupted by the discovery of new ones and new continents. Maritime exploration and the political evolution of the European nation-states tended to suppress intermediaries and favor national industries.

Alum most Christian

In the mid-15th century, alum, the premier mordanting mineral, became a rare commodity in Europe. The expanding Turkish empire gained control of many of the most important alum mines and imposed heavy tariffs on its export. Subjected to larger and larger tribute payments, the Genoese Maona withdrew from Chios, and the Turks took over production. The Western wool industry experienced a dramatic shortage of alum, whose price quintupled. At this very moment, rich alum mines were discovered at Tolfa, near Civitavecchia, in the Papal States of Italy. Pope Pius II promptly began to exploit the lode vigorously, exporting to all the markets of Christendom and earning an estimated income of 300,000 gold ducats a year. The profits were allocated to finance a crusade against the Turks. The pope forbade Europe to import Turkish alum, in favor of his crusade alum, which was, fortunately, of excellent quality.

The Tolfa mines were run on leased concessions. To possess Tolfa thus meant to control an alum monopoly sanctioned by the papacy, and it became the focus of a great struggle between Florentine and Genoese bankers. Among the happy winners of the contest were the Medici of Florence, who built their great fortune on alum, and the Sienese Agostino Chigi (1465?–1520), considered the richest merchant of his time in Italy.

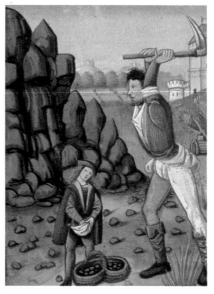

Alum is a vitriolic clay composed of sulfuric acid, aluminum, and potassium. It comes in many variants, including rock alum, Yemenite alum, Roman alum, and shale alum. It was used as a mordant for dyeing throughout the ancient world, including India. Until the 15th century, it was processed mainly in Constantinople, Aleppo, and a site near Smyrna (modern Izmir) called Rocca. In the mid-15th century, a Genoese merchant who had traveled to the East and spent some time in Rocca founded the first alum factory in Europe on the island of Ischia. Above: alum miners at work in a miniature.

From Civitavecchia, alum was exported by Italian fleets to northern cities with a large dyeing industry: Antwerp (600 tons a year), Rouen (500 tons a year), and London (200 tons a year). In 1566, the English, Dutch, and French began to send their own ships to fetch it to London, Rouen, Marseilles (350 tons a year), and especially to the merchant cities of the Netherlands. Roman alum had little real competition until the 18th century, when other, less costly products entered the market: Yorkshire alum and synthetic alum from Liège.

High-stakes trade in the East Indies

The great sea explorers who opened new trade routes east and west were driven by the aim of trading directly with the mythic countries that produced spices and colorants, especially India, the Sunda Isles, Ceylon, China, and Japan. They were looking to avoid paying tolls and taxes to the intermediaries encountered on the land routes. Sea voyages were long (the round trip lasted two years) and dangerous, for one had to reckon with weather, pirates, and the hostility of the merchant communities already established at each site. But the profit was enormous, far outstripping that of traditional point-to-point trade, as

The medieval trading ships that brought alum to Europe also exported European textiles back to the East on the return trip, especially woolen cloth from Genoa and Florence. Since alum was heavy, its transport was expensive—about 16 percent of the selling price. Alum cargos were often rounded out with lighter merchandise with a high added value, such as spices, indigo, exotic dyestuffs, and silk. Below: Arab merchants examine dyes and a roll of cloth in an illustration to a c. 1412 edition of Marco Polo's *Le Livre des merveilles du monde* (*Book of Marvels*).

practiced in the Middle Ages by the Venetians—which itself had been substantial.

The transition between the two systems was brutal. In 1504 the Venetian merchant fleet arrived as usual in the East and found nothing to buy. The Portuguese mariners Vasco da Gama and Pedro Alvares Cabral, sailing in well-armed 1,000-ton carracks, had attacked and destroyed the Arab fleet and conquered the Arab merchant cities of Hormuz and Malacca, the intermediate transit points of the traditional route. Once Portugal controlled these centers, it controlled the trade that passed through them. For a while Venice dreamed of opening the canal known as the Prince of the Faithful (at Suez), which had been blocked up by the Arabs in 762 to impoverish Medina after a revolt against the caliph. But this project was not carried out.

Cochineal red: scarlets and crimsons

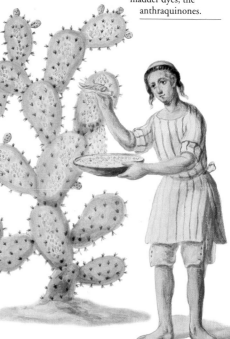

Meanwhile, the discovery of the West Indies (the Americas) overturned the whole of the dye trade, the market for red colorants—madder, cochineal, and brazilwood. Cochineal is a parasitic insect found on certain plants, whose shell yields excellent dyes in a full range of fine, light, waterfast reds. In antiquity it had been mixed with Tyrian purple, and eventually supplanted it. This costly dye produced the vermilion scarlet reserved for the finest wool and silk. With the fall of Byzantium in 1453, the antique purple that was the personal color of royalty and high officials of the church disappeared from the West. In 1467 Pope Paul II decreed that cardinals' robes,

Below: a Mexican Indian gathers cochineal insects laden with eggs by scraping the nopal cacti on which they feed. Above: dried, they become *grana,* source of a red carminic-acid dye, belonging to the same chemical family as the madder dyes, the anthraquinones.

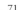

formerly dyed purple, would henceforth be dyed cochineal red.

The provenance of cochineal insects is quite diverse. They were plentiful in Armenia, in the region of Mount Ararat, where, from the 8th century BC on, they were made into dye on site, but were also sometimes exported to Venice, Genoa, and Marseilles. In France and Spain cochineal was known as kermes, where it was harvested in the scrub lands around Arles, in Languedoc. The textile industry of northern Europe bought cochineal from Poland that traveled through the Hanseatic ports on the North Sea to Holland and Flanders. Some of this was also sent by land to Venice and Florence. Montpellier and Venice also bought cochineal lake from Indochina and Burma through Arab merchants. The large trading centers thus sold cochineal from numerous sources. Each cochineal, combined with any given mordant, made a different shade of red. Dyers tried to offer the maximum number of shades in a range of hues, and as Europe's wealth increased, the popularity of these colors continued to rise.

This prosperous trade was suddenly overwhelmed in the 16th century by the importation on a massive scale of cochineal from the Americas. Soon after their arrival, the Spanish discovered regions in Mexico and Honduras where prickly-pear cactus, on which the cochineal insect fed, was cultivated. Indeed, the use of cochineal dye was known long before in Central and South America (in Peru it dates to 400 BC), and the

In this c. 1517 painting, the painter Raphael portrays Pope Leo X (Giovanni de' Medici) and his two nephews, both cardinals, in shades of vermilion and crimson. Even the tablecloth is a sumptuous red. The pope's robes of deep cochineal crimson are a reference to the purple robes of the ancient Roman emperors, underscoring both the power and glory of the papacy and its connection to the imperial Roman past.

Overleaf: Venetian dyers at work in an 18th-century genre scene.

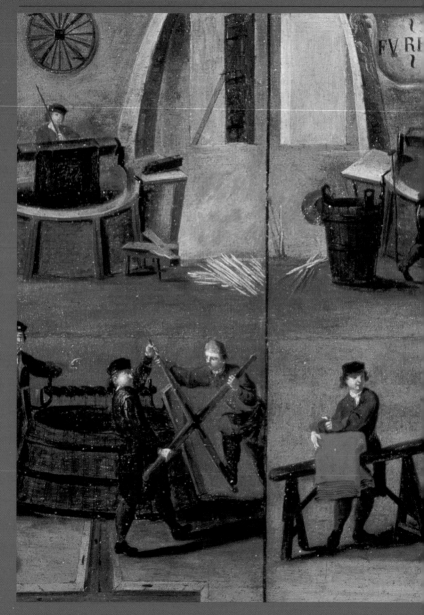

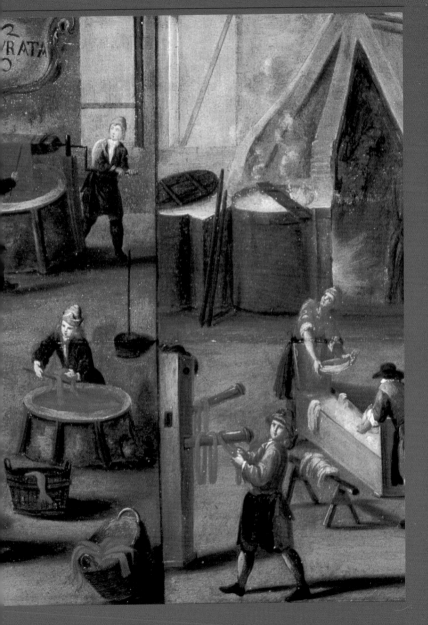

word cochineal derives from the Aztec name for the dye, *nochezli,* or blood of the prickly pear, transcribed by the Spaniards as *cochinilla.* Spain rapidly developed the cochineal crop and exported the dye product, called *grana,* or grain, to Spain.

In 1560, the galleons that transported gold, silver, and cochineal unloaded 115 tons of *grana* in the hub city of Seville. By the 17th century, production was so plentiful that Mexico exported directly to the Philippines and China, where American *grana* began to supplant local cochineal lake. Cochineal crimson became immensely popular; at Versailles, Louis XIV set a fashion for luxury, covering his walls and armchairs and hanging the curtains of 435 royal and princely beds with ruby damask.

The evolution of painting techniques

Works of art were also a luxury item. By the 16th century, paintings and fine objects for private use were proliferating, and the range of supports and materials used by artists broadened considerably. Whether for mural painting, wood panel, polychrome sculpture, enamelware, or ceramic object, pigments had to adapt to these new supports and techniques. Among the innovations were the use of linen cloth stretched over a frame and primed with a refined preparatory ground, called the *imprimatura;* the use in paints of new oil binders and other emulsions, such as egg tempera; and varnishes to accentuate effects of light and shadow. All of these required new or modified coloring agents. Linseed or poppy-seed oil, for example, when used as a medium for pigment did not produce the same optical effects as egg white or hide glue, but made many colors translucent. Basic lead white retained its durable opacity and covering properties, but it partially oxidized in linseed oil, which aided in the drying of the painting. Cochineal or brazilwood lakes could be used as thin paint glazes over other colors to modify their look while producing subtle effects of depth.

Aside from technique, painters became concerned with the permanence of their colors, rejecting those thought to

Prices for pigments were often very high, especially for imported colors such as lapis-lazuli blue and vermilion red, and falsifications were frequent. Many technical recipes advised painters how to distinguish true colors from false.

Until the 18th century, ready-to-use dyes and paints were rare. Pigments, binders, and mediums were usually purchased from a spice seller, called a druggist, and then ground and mixed. Pigments were sold in pastes, nuggets, or dried, compacted cakes. Below: delicate extracts such as buckthorn,

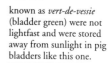

known as *vert-de-vessie* (bladder green) were not lightfast and were stored away from sunlight in pig bladders like this one.

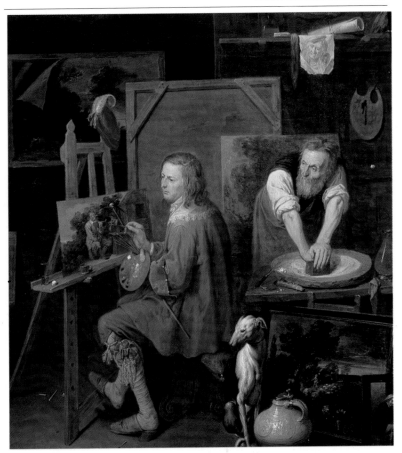

be unstable or incompatible with the new materials. The most reliable colors were still basic lead white, vermilion red, red and yellow ochers, lapis-lazuli blue, tin yellow, copper-based or composite green, and brown and black earths. Yet these too all had defects of one sort or another. Some lacked vividness; others were still rare and expensive.

The last fruits of alchemy

The alchemists, those secretive, mystically inclined chemists, were still very active in the 17th century.

The painter or an assistant prepared pigments from raw purchased materials. Different grindings and mixtures produced different hues and tones. In this 17th-century self-portrait, an assistant grinds white. By the 18th century, pigment merchants began to assume this task.

Scientific progress in other spheres such as the universities, where publication was encouraged, tended to isolate them more and more, but they were still making remarkable discoveries in the field of dyestuffs and mordants. Around 1610, the Dutch inventor Cornelius Drebbel (1572–1633) popularized the use of tin chloride as a mordant for scarlet dyes. In this way shades of carmine could be produced that were similar to those produced with kermes.

In 1668, the alchemist Andreas Cassius, while studying the alchemical transmutation of gold, discovered a gold-based pigment: a rose-violet with an ultrafine colloidal structure, made with gold and tin chlorides. This pink became famous under the name purple of Cassius. In Berlin in 1704, two other practicing alchemists, a paint manufacturer named Diesbach and a pharmacist named Johann Konrad Dieppel (1673–1734), accidentally discovered a dark blue, made from cyanide, potassium, and iron, with exceptional coloring strength, which acquired the name Prussian blue. Manufactured beginning in 1710, it was an immediate success. Chemists all over Europe made variants, some of which were simpler or more stable, such as Parisian blue and Antwerp blue.

The role of the chemists

The scientists of the 18th century at last had the tools necessary to confront many longstanding technical problems in their disciplines. Significant progress was made in optics, botany, and mineralogy, while chemistry evolved in a spectacular manner. The discovery of new elements—such as cobalt (1742), nitrogen, manganese, chlorine (1774), and tungsten (1781)—and compounds definitively raised chemistry from a morass of pseudo-scientific alchemy, medical pharmacy, and imprecise theories to an exact science. Talented experimenters included the Swede Carl Wilhelm Scheele (1742–86), who discovered oxygen and a copper arsenite tint called Scheele's green; the Englishmen Henry Cavendish (1731–1810) and Joseph Priestley (1733–1804); and the Frenchman Antoine-Laurent Lavoisier (1743–94), who

Above: a 1763 illustration from Denis Diderot and Jean le Rond d'Alembert's massive *Encyclopédie ou dictionnaire raisonné des sciences, des arts, et des métiers* (*Encyclopedia of Sciences, Arts, and Crafts*) depicts a chemistry laboratory, complete with instruments: alembics, ovens, and other devices for heating, distilling, and calcining. Opposite: a vial of Prussian blue.

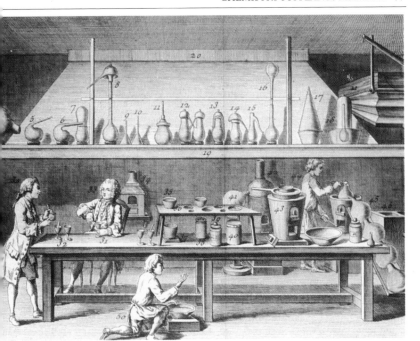

established a uniform system of weights and measures and introduced the use of weighing to the study of chemical reactions.

The century's scholars grew more and more interested in applied research, and a number of chemists became involved in the quest for new pigments and dyes. Notable among these were Claude-Louis Berthollet (1748–1822), superintendent of dyeworks in France, who developed the first method of bleaching with chlorine; Louis-Nicolas Vauquelin, also French, who discovered chromium; Michel-Eugène Chevreul (1786–1889), who studied the psychology of colors; and the Englishmen John Dalton (1766–1844), who studied color blindness, and Sir Humphry Davy, who researched the bleaching action of chlorine, among other achievements.

In 1791, Berthollet published an influential book, *Elements de l'art de la teinture* (*Elements of the Art of*

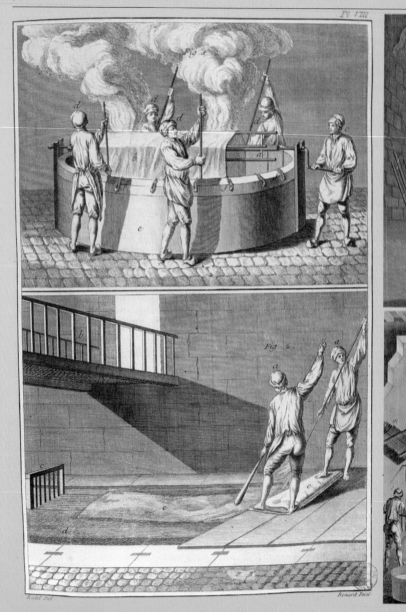

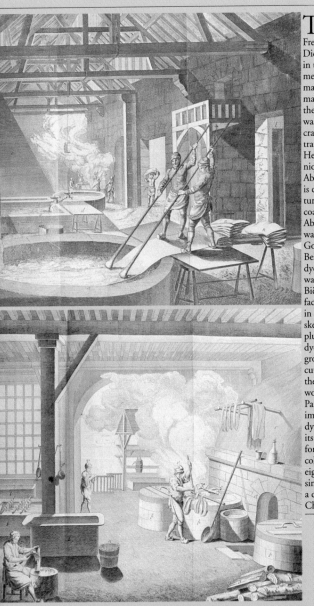

The *Encyclopédie* compiled by the French philosophers Diderot and d'Alembert in the 18th century meticulously assembled many volumes of information about the state of the sciences and arts. It was arranged by types of crafts and heavily illustrated with engravings. Here, we see the techniques of dyeing in detail. Above, far left: the cloth is dyed in a dye vat with a turnspit, to ensure even coating of the color. Above, near left: cloth is washed in vats at the Gobelins Tapestry Works. Below, far left: after the dye bath, the cloth is washed again, in the Bièvre River, near the factory. Below, near left: in a silk-dyeing workshop, skeins are about to be plunged into the heated dye bath; in the foreground, a seated worker cuts wood-shavings for the furnace. The Gobelins workshop, founded in Paris in 1450, was an important center of wool dyeing. It was famous for its brilliant scarlet, and for its great range of colors: in the 17th century, eighty were used for a single tapestry based on a design by the artist Charles Lebrun.

Dyeing). Chevreul was appointed director of dyeworks at the famous Gobelins Tapestry Works, an important center of art dyeing. There, he studied not only chemistry, but the perception of colors. He created the first chromatic color wheels and established the law of contrasting and complementary colors that today is familiar to all art students. He did groundbreaking research in animal fats, soaps, and waxes, as well as pigments, and was frequently harried by the Gobelins artists for better and more consistent dyes. He concentrated on creating a specific, identifiable set of colors that could always be matched. To this end, he introduced a color-classification system that is also still in use today, using the categories of tint, hue, and saturation. Color value was determined by degree of intensity and degree of purity or grayness. He defined color intervals and expressed them in chromatic circles, a forerunner of the color wheel, and other scales.

Thanks to the chemists, it was now possible to produce synthetic alum in large quantities, and the Roman monopoly on the mineral was broken. Roman alum was nevertheless still considered the best. Various chemists analyzed natural and synthetic alum from France, England, and Italy; the only difference lay in the iron content, which affected the shades obtained during dyeing.

The quest for a new yellow

Good yellows were still lacking in artist's paints. In the 17th century, the Italians perfected the manufacture of a warm yellow from lead antimoniate, called Naples yellow. First made with a mineral found on the slopes of Vesuvius, it was soon prepared artificially by fusing a mixture of antimony, potassium, lead, and sea salt in a crucible. For his part, Scheele obtained a bright light yellow by calcinating a mixture of litharge (lead oxide), sea salt, and soda. The fabrication of this compound was

Bright yellow pigments were prized by artists, for they were essential in depicting gold and effects of light. Until the mid-18th century, the best available yellow was one made from tin. Georges de La Tour used it in the 17th century in this detail from *Cheater with the Ace of Diamonds.* Later, it was replaced by Naples yellow. Modern chemical analysis allows art historians to identify and date pigments and binders. The presence of a 19th-century chromium yellow in an older painting, for example, indicates a

restoration, a copy, or even a forgery.

Watercolors and other paints that are to be used in thin washes present a challenge to the color chemist, for the pigments must disperse easily and evenly in water, and remain translucent. The addition of gum tragacanth improves their brilliance while helping to affix them to the paper. Popular new colors among watercolorists were Prussian blue, sea green (an acetate of copper), Indian yellow, superfine ochers, siena earths, and sepia brown (a color made from cuttlefish, and often counterfeited with chimney soot). Left: notes made in 1809 by George Field, an English researcher, on types of

yellow. Above: Indian yellow was made from a concentrated extract of the urine of cows fed entirely on mango leaves. It was unfortunately not healthy for the cows, and in the 19th century was replaced by chrome.

patented in England in 1780 by an industrialist named Turner, who sold it under the name patent yellow.

A popular theory of the time asserted that the harmony of a design depended on using colors with equal saturation. Of the three primary colors, red, yellow, and blue (from which most other colors could be mixed), bright red and blue were available, but no equally bright yellow. In 1765, an orange-red mineral called Siberian red lead (crocoite) was discovered in the Ural Mountains. When ground, it was used as an orange pigment by some artists. In 1797, Vauquelin was given a sample of it to analyze. He detected a new metal, which he isolated and named chromium, or chrome (Greek for color), due to its extraordinary capacity to produce salts in many

colors. One of the best colors made from chrome by Vauquelin was a fine bright-yellow pigment of lead chromate, opaque and easily manufactured. At last an ideal yellow pigment was available. (Vauquelin also invented the brilliant emerald color called viridian green, using chromium.)

But Siberia, source of the base mineral, is far from Europe. In 1804, a lode of "chromated iron" was found in France. In 1816, a disciple of Vauquelin named Kurtz began manufacturing chromium-based pigments. In 1822, in Manchester, a second manufactory followed, which made the famous English greens, mixtures (actually coprecipitates) of Prussian blue and chromium yellow. By the mid-1800s, the manufacture of chrome pigments had proliferated: in France in 1818, Jean-Henri Zuber founded the first factory producing chromium yellow and greens for wallpaper; in Paris around 1840, the manufacturer Milori created a series of greens made of Prussian blue, chromium yellow, and barium sulfate white. Gradually, as the century progressed other sources of yellow were also found, including American fustet, annatto, and quercitron, which supplanted weld.

Pigments in the Industrial Revolution

The industrial production of other colors also developed rapidly in the latter 18th century and the first half of the 19th. Among the bright new colors were Burgundy violet; ultramarine violet and blue; cobalt blues; chromium greens and reds; copper and arsenic greens; Mars yellow, orange, and red; zinc whites; and a number of lead whites, the foundation color in all painting and especially in the paint used for walls, rooms, and furniture. Chemists were very active in this emerging industry. Far from contenting themselves with the discovery of new pigments, they also perfected new procedures for making them industrially and on occasion invested in the businesses.

A case in point is the development of lead white, an ancient color essential to artists and other users of paint, but highly toxic. In Dijon in 1781, the chemist Bernard Courtois (1777–1838) manufactured the first zinc white

In this early 19th-century genre scene, a printer of wallpaper and his child assistant press a roller across a woodblock. Yellow ink for the block is in a tray behind them, and other blocks rest on the floor. In the background another worker brings rolls of blank paper to another printer. At far left, the variety of colored prints obtainable with movable woodblocks may be seen.

in an attempt to produce a white that was less poisonous than that made with lead. Unfortunately, the latter was less costly, covered better, was easier to use, and remained the preferred white pigment. Most lead white was manufactured in England and Holland. The Dutch process followed ancient recipes in which strips of lead, called lames, were exposed to vinegar fumes, then to carbonic

Wallpaper was by definition a form of decoration that could readily be changed; its colors therefore did not need to be as stable as those used in a quality cloth. Often they were inexpensive, easy-to-use paste inks made from domestic vegetable colors: weld or yellow lake, madder or brazilwood, indigo or logwood reds, and some toxic greens made from copper and arsenic.

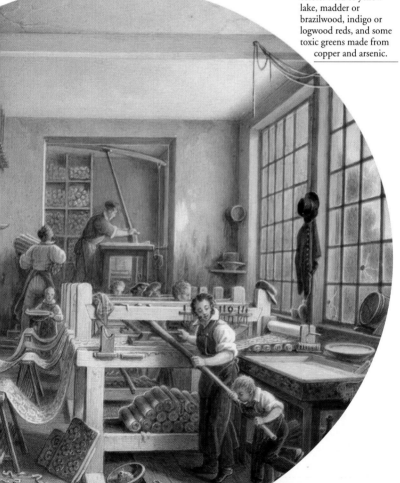

gas. The sulfurous fumes were extremely dangerous and also tended to compromise the quality of the white, since sulfur sometimes caused the paint to darken. A variant devised in Germany avoided the emanation of fumes, but was expensive to produce. Called Kremnitz white, it was used mainly in luxury decorations and fine artist's pigments. In 1801, the chemist Louis-Jacques Thénard (1777–1857) perfected a quicker and less costly process that permitted production of large, consistent quantities at an industrial level. He also created a fine blue pigment, called Thénard blue, that was used in porcelain glazes.

Other manufacturers sprang up, and many of the companies they founded remain in the forefront of pigment research and production. In France, Frédéric Kuhlmann manufactured chemical products and coloring agents industrially, including silicated pigments used for housepaint and a synthetic green pigment with a copper-chloride base, called Kuhlmann green. The Kuhlmann firm survives to this day. The English firm of Winsor & Newton, inventor of a colorfast opaque watercolor white called Chinese white, was founded in 1832,

The chemist Michel-Eugène Chevreul, director of dyeworks at the Gobelins Tapestry Works, in a portrait by Léon-Auguste Tourny, official painter at the Gobelins factory in the 1800s. Left: Chevreul's colorimeter, a device for the precise measurement of hues.

and today still produces fine artist's paints and pigments. The French firm of Sennelier, beloved of the Impressionist painters, was founded in 1887, and is also still in operation. One of today's most renowned manufacturers of paints, inks, and pigments for artists, Lefranc & Bourgeois, was originally a pigment and spice shop, founded in Paris in 1720 by the artist Jean-Baptiste-Siméon Chardin and the pigment maker Charles de La Clef.

Industrial dyeing and printing on wallpaper and cotton fabrics

Printed wallpaper first appeared in the 17th century and soon became very popular. Its designs and colors often imitated the rich fabrics imported from the East—India, China, and the Arab countries. It was originally printed by pressing individual sheets of paper onto woodblocks, but the process was improved with the invention of woodblock stamps and paper made in 10-yard (or 10-meter) rolls. In Paris in 1760, velvet and damasked papers were all the rage, and were produced by more than thirty manufacturers.

Left: a Chevreul color circle made with wool fibers. His studies of color perception led to the law of contrasts that notes the effect of varying color juxtapositions. This in particular influenced the Pointillist painter Georges Seurat (1859–91) and, later, the Bauhaus artist Josef Albers (1888–1976).

A blue invented by J. B. Guimet in the 19th century was far less costly than ultramarine, and was frequently used as blueing, a bleaching agent for the paper industry and for laundry. Below: balls of blue used for washing and a box of Guimet blue pigment.

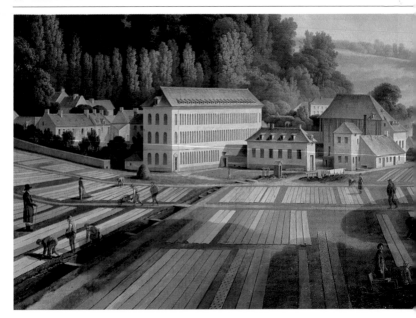

If artist's paints proliferated in the 18th and 19th centuries, dyeing benefited even more from the boom in new research and processes. Engineers in England, Germany, and Holland, especially, perfected new manufacturing techniques. As the textile industry throughout Europe and America grew more mechanized, processes for dyeing cloth also evolved. New dyestuffs and mordants were found, as well as other treatments for the dyeing of wools, silks, and linens.

Among the many innovations were those in the field of printed textiles. Beautiful multicolored printed cotton, called calico (from the Arab word *qoton,* which also means cotton), had been made in India for centuries, as Marco Polo noted in 1295. India, too, had been one of the original sources for indigo and madder dyes. Portuguese importers (and later the East India Company) brought large shipments of calicos to Europe in the 1600s, but it was only during the Industrial Revolution that cotton, much of it from the United States and India, was imported in large quantities into

A factory in a field: this is how the Jouy-en-Josas factory appeared in 1807, painted by Jean-Baptiste Huet; Christophe Oberkampf appears at lower right. Huet also created many textile designs. The buildings—offices, warehouses, laundry, laboratory, and cart shed—were arranged in a scientific manner: the large building at left housed the printing studios. Nearby, cloth is drying on a rack. In the foreground, workers spread out lengths of newly printed cloth to bleach it in the sun.

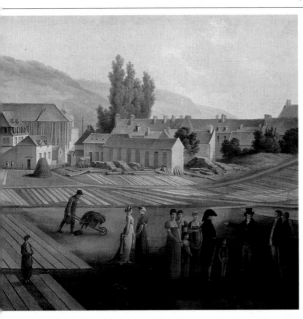

Originally imported from the East, printed cotton fabrics were long known as Indian or Persian calicos and chintzes. In the 18th century, they were block-printed using sets of carved blocks with a raised design. Oberkampf was the first, in 1801, to print fabric with engraved copper rollers. This invention allowed for much faster printing with a greater number of colors. Below: samples of modern printed cotton calicos based on antique designs. These use red and green dyes in a range of strengths and overlays.

Europe for textile manufacture there. Cotton made a light, popular cloth whose smooth texture was receptive to printed patterns. Then the taste for multicolored printed cotton fabric exploded. However, the process for dyeing fabric with many colors was complex and difficult. In the 18th century, several inventors began to find ways to do it effectively.

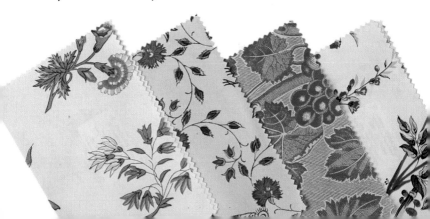

Christophe Oberkampf, the son of a Bavarian dyer, patented a technique for printing cotton fabric. In 1759, he founded a small workshop in the town of Jouy in northern France. There he perfected processes of weaving and block and roller printing, constructing the necessary machines for the production of printed calicos and chintzes. His success was phenomenal, and the fabric came to be known as Jouy cloth. Other manufacturers followed suit, and the weavers of silk, wool, linen, and velvet suffered; in consequence, heavy taxes were imposed on cotton cloth. Nonetheless, single-color and multicolored printed fabrics remained popular and were made not only in France, but in England, Germany, Switzerland, and elsewhere. In the Alsatian town of Mülhausen (now Mulhouse), the dyer Samuel Koechlin founded a textile-dyeing company in 1746. In 1811, Daniel Koechlin developed a method for resist-printing with the difficult, much-prized red called Turkey red and the rich Parisian blue; and he soon found ways to create multi-colored printed fabrics by manipulating a variety of mordants, resists, bleaches, and dyes. Whatever the particular dyes or printing methods, the basic principle of multicolored printed fabrics was to print mordants, thickened with gum, on designated areas of the cloth, before dipping it in a dye bath.

Treatises on dyeing in the 19th century were commonly accompanied by fabric samples, sometimes hundreds of them. Below: notes on alum mordanting in an 1838 laboratory diary from Mülhausen.

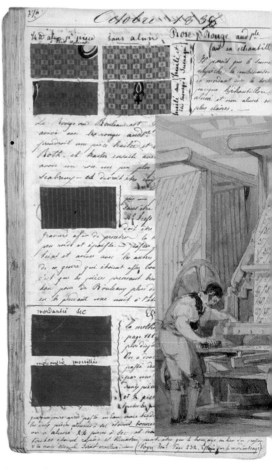

The dye became firmly affixed only to the mordanted parts, only lightly coloring the rest of the fabric. When the fabric was rinsed in water and bleached in the sun, the unmordanted areas returned to white. The process was then repeated with another color.

Alsace and the Swiss canton of Glarus became centers of calico manufacture. The red printed-cotton fabrics produced there—especially handkerchiefs—were immensely popular worldwide; among other things, they were the basis for the red bandanas worn by American cowboys in the 19th century.

Following upon the use of increasingly mechanized processes and the spread of new factories, the principal characteristic of 18th- and 19th-century industry was a notable growth in the quantity of goods produced. To supply the new textile mills, manufacturers began to produce raw and finished dyes using industrial methods.

In the 19th century, the textile industry grew and became mechanized very rapidly, sometimes leading to social unrest, as in the Luddite riots in England in 1811–16. The manufacture of printed cotton fabric saw great innovations. Oberkampf's textile roller was perfected by manufacturers in Manchester, England, whose system combined cylinders of relief woodblocks and those of etched copper, which allowed for the creation of new effects. Dyes, too, were developing fast. Below: workers printing cotton, c. 1835.

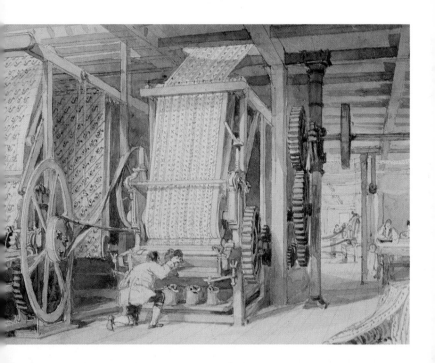

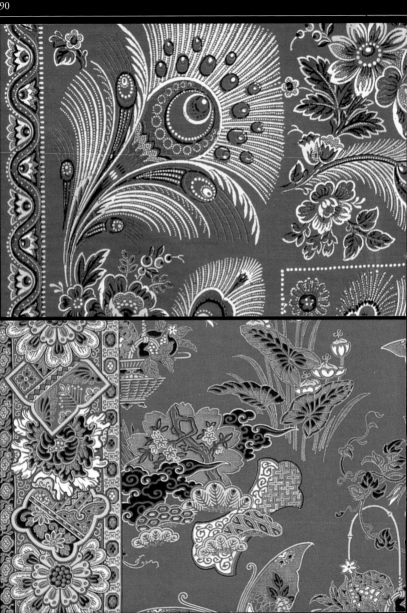

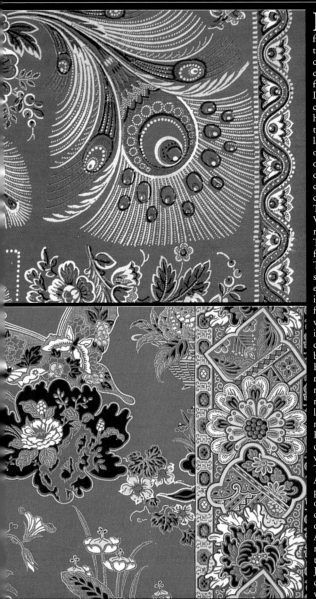

It was comparatively easy to dye animal fibers red, and red wool textiles are found in cultures worldwide, but cotton and other vegetable fibers were more difficult. Indeed, until the 17th century, only India knew how to dye cotton red, a technique practiced on a large scale. When the use of cotton spread throughout Europe around 1700, dyers were eager to discover India's secret, commonly known as Turkey red (also called Venetian red, Pompeiian red, and Persian red). The process was long and followed many stages. The fabric was alternately soaked in animal fats and excrement and air dried, in order to prepare the fibers for mordanting with alum. The dyeing itself was done in a madder bath to which bull's blood was added. In Europe the cultivation of madder had fallen into neglect, but was soon revived, and became very lucrative. In 1750, the northern French city of Rouen brought Greek dyers from Smyrna and was the first to produce Turkey red in Europe. In Alsace, Daniel Koechlin pioneered the technique of printing black over the color, and of bleaching out the white areas. Above: a late 19th-century red printed cotton from the firm of Blumer and Jenny; below: a Koechlin cotton with black and white areas.

The golden market for indigo

Faced with the massive importation of Indian indigo by Portuguese and Dutch merchants in the 18th century, European governments sought to protect their local pastel and woad industries with restrictive laws. These were as vain as the laws penalizing cotton. So superior was indigo to domestic blue dyes that its use rapidly became widespread and producers of pastel and woad were ruined. The Spanish, French, and English were able to enter the lucrative indigo market by cultivating indigo in their American colonies: Spanish Guatemala and Mexico, the French Antilles, and the English Carolinas.

Much of the Caribbean indigo made its way to Marseilles, which became a shipping hub supplying textile mills in Italy and Switzerland. Indeed, through Marseilles, American dyes were transshipped east as far as Smyrna, Aleppo, Constantinople, Salonica, and Egypt. The volume of the trade was enormous: an average of 44 million pounds (200,000 quintals) a year between 1764 and 1775. In 1771, Bordeaux imported 18,000 hundredweight of indigo from Santo Domingo (now the Dominican Republic), with a value greater than the rest of its imports from the Antilles combined, including sugar. In spite of the outbreak of the American War of Independence, with its attendant shipping blockades, this commerce remained highly profitable, and continued until the French Revolution.

Britain conquers the indigo trade

Indigo produced the most lightfast and fadeproof color; it is no accident that many national armies chose its handsome, resilient blue for their uniforms. Napoleon's Grande Armée imported 150 tons of indigo to dye the uniforms of 600,000 soldiers a year. During the Napoleonic Wars, the British blockade made American indigo impossible to obtain. In response, the French attempted to revive the pastel industry. In 1811, 14,000 hectares were devoted to its cultivation, and chemists worked to extract the best possible indigotin from the plant. A prize of 25,000 francs was offered to "anyone who discovers a way to extract from an indigenous, easily cultivated plant a dye whose cost, use,

"I trust people will be grateful to me for bringing [the art of dyeing] out of the obscurity in which it was buried, and for having made it possible for physicists and even dyers to make discoveries and perfect a very useful art, of which it seems to me people have only a very vague idea.**"**
From the preface of Jean Hellot, *L'Art de la teinture des laines* (*The Art of Dyeing Wool*), 1786

A bove: title pages of two treatises on dyeing by French chemists.

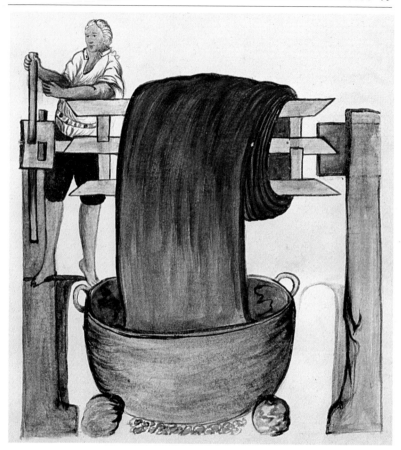

brilliance, and evenness are equivalent to indigo." Such a dye must remain "colorfast, vivid, and stable when worn and washed in water."

Unfortunately, the pastel industry did not survive the restoration of peace. In the 19th century, the British developed indigo factories in India and became the foremost producers in the world. Some regions of India, such as Bengal, became heavily dependent upon indigo production, and this led to periodic famines and revolts in regions of monoculture, such as the 1860–67 Indigo War.

Indigo dyeing used techniques quite different from those for red. No matter what kind of vat or indigo was used, the cloth was always green when it came out of the bath, and did not turn blue until exposed to the air. Above: a Peruvian dyer at work.

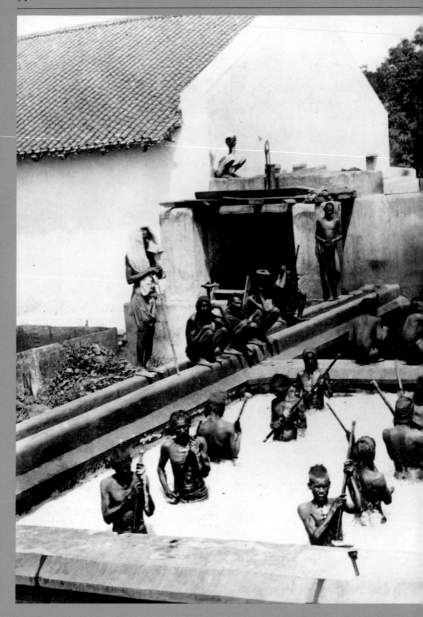

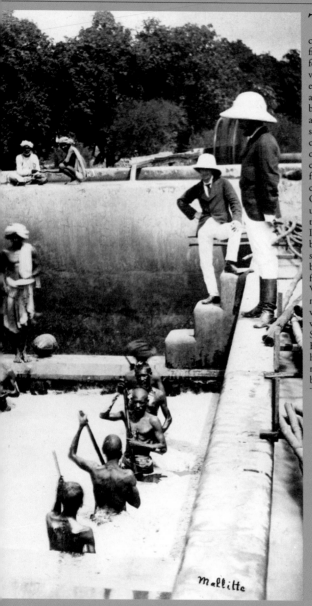

mallitte

The traditional process for making indigo comprised three stages: first, the leaves were fermented in a steeping vat; then a liquid was extracted and oxidized in a beating vat; from that, a blue precipitate was allowed to form in a settling vat and then collected, dried, and compacted. In the 19th century, English indigo factories in India cornered the market. Often they were unmechanized—despite the innovations of the Industrial Revolution—because cheap labor was so plentiful. Left: a beating vat in an English factory in Bengal, c. 1877. Waist deep in a nauseating liquid, Indian workers air the mixture with wooden sticks. Specialists, the standing Englishmen wearing pith helmets, chose the exact moment to stop the beating.

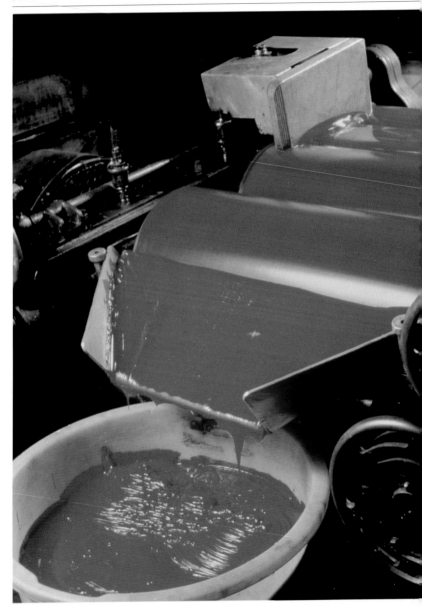

For a long time, applied-research chemists sought to isolate and characterize the principles of dyeing. As they began to succeed, the vast possibilities offered by chemical synthesis overwhelmed the colorant market. Large-scale agricultural production of dye plants gave way to the manufacture of synthetic pigments and dyes.

CHAPTER 4

THE TRIUMPH OF INDUSTRIAL CHEMISTRY

Aside from the ochers, which are mined, today's pigments, lakes, and dyes are produced by specialized chemical industries. The first synthetic dyes appeared on the market in the middle of the 19th century. Among them was alizarin, isolated as one of the main coloring agents found in madder. Left: the production of red paint; right: an early label for synthetic alizarin.

During the first decades of the 19th century, numerous chemists attempted to extract the coloring elements in dye plants in order to identify them. In this regard, Chevreul was one of the first and most talented. He was most interested in dyewoods (camwood, logwood, fustet, and quercitron) and weld. In 1826, Pierre-Jean Robiquet (1780–1840) isolated alizarin from madder, and then orcin (archil). From these first steps followed dozens of discoveries in the chemistry of pigments and dyes.

Synthesizing colors

In Germany in 1826, the chemist Otto Unverdorben (1806–73) extracted a pure substance from heated indigo and named it aniline, from *anil,* the Spanish word for indigo. In 1853, at the Royal College of Chemistry in London, a 15-year-old Englishman named William Henry Perkin (1838–1907) attempted to synthesize quinine from aniline. Perkin noted that one of the products of the reaction was violet and ascertained that it was an excellent coloring material for wool and silk. In 1856, he patented mauve, the first synthetic dye in the world, and began to manufacture it, under the name mauveine, at a factory in Greenford Green, near London.

Aniline arrives

His success drew the attention of chemists to the possibilities of aniline and its derivates. In Lyons in 1859, François-Emmanuel Verguin synthesized a brilliant cherry-red color similar to that of the fuchsia flower. He patented it under the name of fuchsin, and the Renard and Franc company acquired the rights to manufacture it. In spite of an initial high price, fuchsin created a vogue for bright dyed woolens in colors called fuchsia, magenta, and solferino. And that was just the beginning. In 1860, several English chemists developed an aniline

Wood fibers with coloring properties, known as the tinctorial woods, played a very important role in the textile industry. Among these are logwood (whose heartwood produces red and brown), quercitron (a black oak whose bark produces yellow), and brazilwood (which renders a red tint). Michel-Eugène Chevreul used chemistry to isolate the principal coloring agents of many of them. Below: samples of dyewoods used by Chevreul.

Right: mauveine won prizes at the 1862 Exposition Internationale, an important international world's fair, or trade fair, where William Henry Perkin exhibited this shawl, and Queen Victoria wore a dress dyed the same color. The French Empress Eugénie responded by sporting a silk dress at the opera dyed a luminous new synthetic green, produced by the Renard company.

black by means of an oxidation process that is still used today. In 1861, August Wilhelm von Hofmann (1818–92) heated fuschin with various other substances, including aniline, ethyl iodide, and methyl chloride, to obtain synthetic violets, greens, and blues. In 1862, the first true synthetic green dye, aldehyde green, was developed. These colors were outclassed in 1866 by Hofmann's less costly iodine green and Paris violet. Patents proliferated, especially in England, France, and Germany. Differences in patent law among these countries led to a particularly robust development of the synthetic-dye industry in

William Henry Perkin began his illustrious career (including the synthesis of alizarin) at age 15 and ended it with a knighthood. He stood for his portrait holding a skein dyed with the mauve that had made him famous.

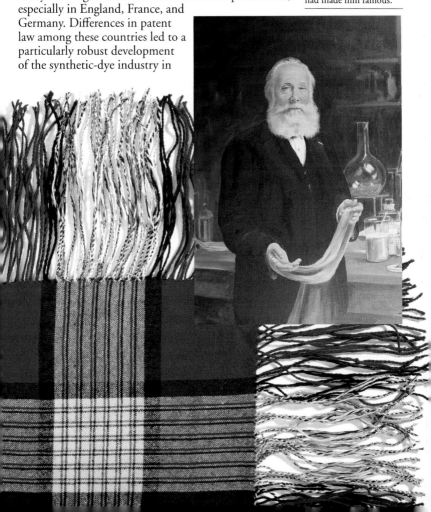

Germany. The aniline dyes had great color intensity and were easy to use.

The birth of organic chemistry

A new discipline emerged at mid-century: organic chemistry. Until this point, chemistry had been essentially the science of minerals. It was conceptually poorly equipped to study the complex structures of carbon and hydrogen found in living matter. But in 1858, three chemists, the Russian Aleksandr Butlerov (1828–86), the Scot Archibald Couper (1831–92), and the German Friedrich August Kekulé (1829–96), all independently pursued a project that many of their colleagues dismissed as utopian: to describe the structure of molecules and the links that form the basis of molecular structure. They ascertained that a carbon atom must be linked to four neighboring atoms. In 1866, Kekulé published a landmark work that described the benzene molecule and formulated the closed-chain, or ring, theory of its molecular structure. On the basis of these concepts, he explained the structure of benzene-based compounds, later named the aromatics. These form the source of many synthetic dyes.

Organic chemistry, which has an illustrious place in the history of medicine and many other disciplines, was thus born into the rainbow-hued world of the dye industry. Many of the most eminent chemists of their time, including Hofmann, Charles-Adolphe Wurtz (1817–84), and Emil Fischer (1852–1919), devoted themselves to the graphic representation of molecular structures, the systematic study of the major types of organic chemical reactions, and the study of colorants.

This proved to be an immensely fertile field. In 1876, Otto Witt

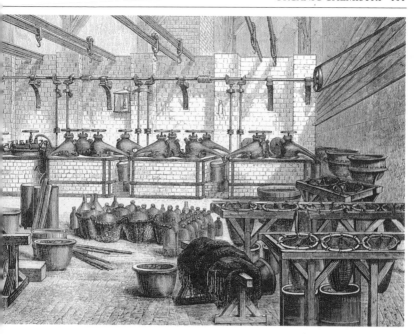

(1853–1915), a student of Hofmann at the University of Berlin, proposed the first theory explaining the coloration of aromatic molecules by the presence of chemical structural types called unsaturated functional groups. He demonstrated that specific chemicals made dyes soluble in water and created chemical bonds with the surface of the fibers, and that these were the processes that gave colored substances their tinctorial properties.

The war of the reds

In 1869, Carl Graebe and Carl Liebermann, two German chemists working at the Badische Anilin und Soda Fabrik, or BASF (an aniline and soda manufactory in Baden, near the French border), isolated alizarin, the principal coloring agent of madder, and determined its structure. By an odd coincidence, they applied for

Dyes can only be produced economically if the intermediary compounds from which they are made are also produced efficiently. The first industrialists to understand this were the Germans. Above: an aniline factory in 1886; opposite: Friedrich August Kekulé and his hexagonal benzene ring. Applied chemists understood that to synthesize aniline, it was necessary to replace one of benzene's hydrogen atoms (H) with one from the NH_2 group.

a patent for alizarin in London on the same day as did Perkin, and they joined forces to market it. To say that this synthetic red was a success is an understatement. By 1872, synthetic alizarin, manufactured by the German chemical firms of BASF, MLB (Meister, Lucius, and Brüning), and Bayer, represented 50 percent of the total manufacture of dyes in Germany, and was sold in vast quantities throughout Europe and elsewhere. Synthetic alizarin production ruined the traditional cultivation of natural madder in Holland, Alsace, and France in less than fifteen years. In 1881, the French district of the Midi produced more than half the world's madder; in 1886, it sold none. It is interesting to note that the success of German synthetic red and the collapse of the natural-red industry in France occurred in the aftermath of the Franco-Prussian War of 1870–71, and was therefore seen as a highly political event. However, companies in Switzerland and elsewhere also enthusiastically produced synthetic dyes and dyed textiles, for the market for them was insatiable.

Aniline dyes oust cochineal reds

A fierce competition now arose among English and German chemists to discover new coloring agents, spurred by the extraordinary boom in the textile industry in general. In 1857, the Englishman Peter Griess discovered a new type of diazotization reaction. The series of aniline dyes derived from this process is countless.

In 1878, a red aniline color for wool was developed. Hofmann analyzed the dye and published its means of manufacture. The energetic German factories launched into low-cost poppy and scarlet reds that

Although experimental forms of color photography had existed as early as the 1870s, the Lumière brothers, Louis and Auguste, invented the first true color photographic process in 1904, called the autochrome. It used a dyeing process that coated the image with juxtaposed granules of potato starch dyed in the three primary colors. The Lumières used

synthetic colors for their dyes: crystallized flexo blue and violet for the blues; tartrazine (yellow) and acid blue 93 for the greens; erythrosin and di-iodofluorescein for the reds. The blues tended to fade in the light. Above: a magnification of an autochrome, showing the 10-micron granules of dyed potato starch. Left: a vial of alizarin from the BASF archives.

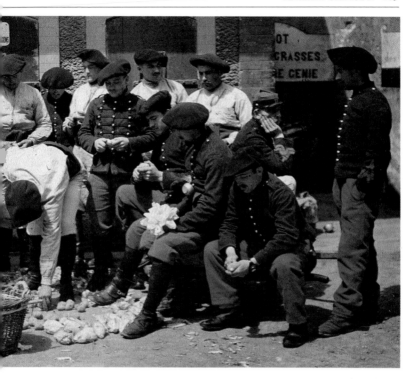

ousted the expensive cochineal from the wool-dyeing industry.

Until this point, the synthetic dyes easily dyed protein (animal) fibers, such as wool and silk, but were applied to cotton only with difficulty. However, in 1884, a dye called Congo red was invented that worked well on cotton. The market for cochineal reds promptly collapsed, although Armenian cochineal, which was extraordinarily abundant, was less affected than the others. The synthetic dyes offered lower cost, greater colorfastness, and more consistency. What was lost with the disappearance of natural madders, indigos, and cochineals? The variability of the natural mixtures, their subtle nuances, and a certain quality of unreproducible individuality: the touch of the dyer's hand.

Madder red brought a bright note to military uniforms, which was especially effective on parade in times of peace—hence the famous British redcoats—although it was also supposed to hide blood-stains in war. Above: French soldiers in World War I, before 1915, when they began wearing blue breeches.

The difficult synthesis of indigo

In 1878, Emil Fischer and his brother determined the structure of fuchsin, and were then able to develop a scientific method of synthesizing it. This type of procedure was repeated by chemists in search of many new synthetic colors. The great challenge that remained was to synthesize the king of colorants, indigo, and thereby end the English domination of the world market. In 1897, 1.7 million hectares of Indian land

With the increase in chemistry research on color composition came a plethora of new publications, not only in organic chemistry, but also in other aspects of color research. Thomas Young, an English physician, studied the effect of colors on the retina in 1801; his

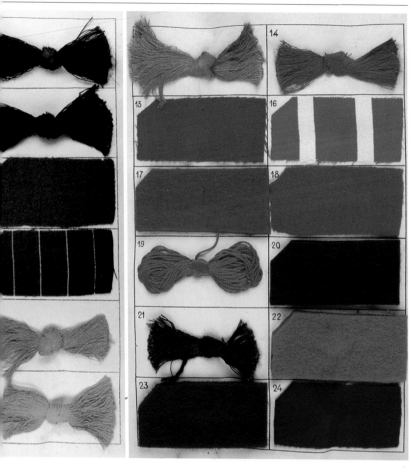

were planted with indigo plants. Of the 400,000 tons of indigo produced, half was exported, the other half used in the local cotton-textile industry. Like other countries, Germany imported this natural indigo (1,400 tons around 1900). In 1880, the German chemist Adolf von Baeyer (1835–1917)completed the synthesis of indigo in his laboratory, but could not find a synthesis that was cost-effective on an industrial level. It took the collaborative efforts of chemists at MLB and BASF more than twenty years of

theory of color perception was modified by the German anatomist Hermann von Helmholtz in the 1850s. O. Piequet issued *The Chemistry of Dyes* in 1892. Above: wool samples from Piequet's treatise guide dyers in judging color quality and techniques.

One black or many?

No coloring agent yields a perfect black; blacks are either bluish or reddish—cool or warm. Black absorbs light and no paint or dye can quite achieve perfect absorption. Traditionally, natural blacks were obtained by mixing a very dark red-brown with a dark blue. In the 18th century, improved black dyes were made based on indigo and the tinctorial woods logwood and sumac. These arrived just in time for the 19th century, in which black clothing, with its connotations of morality and modesty, was much prized. Clerics, teachers, members of the legal and medical professions, and domestics all wore black, and as the century progressed it became increasingly stylish. Dandies dressed in black, particularly in the evening (frock coat, or smoking jacket); women wore glossy black silk. The arrival of chromium mordants at the end of the 19th century produced even richer blacks from these woods. Only with the appearance of the aniline and indanthrone dyes were the dyewood blacks supplanted. Far left: detail of a painting by James McNeill Whistler, 1871; near left: detail of a painting by Jean Béraud.

On the frontiers of the impossible: pure white

The ideal support for dye or paint is white. Traditionally, laundry, artist's canvas, and other white textiles began life with a natural, yellowish color and were bleached in sunlight. Berthollet's research on chlorine in the late 18th century led to the first chlorine-based liquid bleaches. A further innovation was optical blueing: to create a bright white and offset the yellow cast of natural whites a slight blue tinting was added. Various blue dyes were used: Guimet blue for laundry, cobalt oxide for ceramic glazes, nontoxic dye for hair. In 1929, fluorescent dyes appeared. These absorb ultraviolet light and re-emit blue. This improved the whiteness of commercial paper and was added to laundry detergents. Far left: bed linens; near left: artist's papers. Above: a label for powdered Lutetia laundry blue.

research, funded by an investment of twenty million marks, to succeed. In 1904, Germany exported 9,000 tons of synthetic indigo, and three times as much in 1913. Once again whole regions were ruined, this time in India and the Caribbean; the English indigo trade disappeared and the shipping trade of Marseilles, wholly dependent upon it, also collapsed.

An embarrassment of riches

The era of the great chemical firms was at hand. Thousands of molecules were patented each year by MLB, Agfa, BASF, Bayer, British Dyestuffs, and others. Most of them were colored, but had mediocre dyeing properties. Some of them, concentrated in powdered pigments, made good lakes. Time would sort them out. We note the discovery in 1880 of the thio-indigos (red-violets) and in 1900 of the quinacridones (red-oranges and red-violets), both widely used in artist's paints and commercial paints. Their good lightfastness and resistance to wear made them ideal for the paints used on automobile bodies, which suffer long exposure to sunlight and weather.

In 1904, German production of colorants represented 88 percent of the world market. Countries whose chemical-dye production started late (the United States in particular) had to purchase from Germany even the basic raw materials and products necessary for setting up their own industries.

The impact on art:
Van Gogh, Gauguin, and others

Corresponding to the development of synthetic dyes were new colored lakes used in painting. At the end of the 19th century, makers of fine-art colors, such as Winsor & Newton or Lefranc, were able to offer a whole range of new, intensely bright artificial colors: methyl violet,

The German firm of BASF manufactured immense amounts of synthetic indigo before World War I. Opposite, above and below: the plant at Ludwigshafen in 1910. The size of this workshop reflects the immense success of the synthetic product. However, the colorant, known as "pure indigo," did not at first conquer the markets traditionally occupied by natural indigo from India, though it entered the vast Chinese market

more easily. Above: a label from 1903 intended for China.

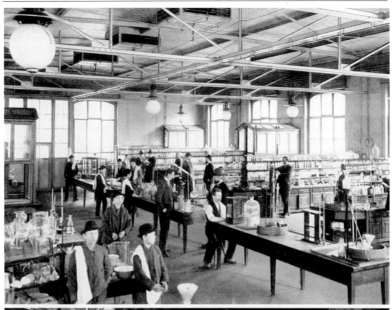

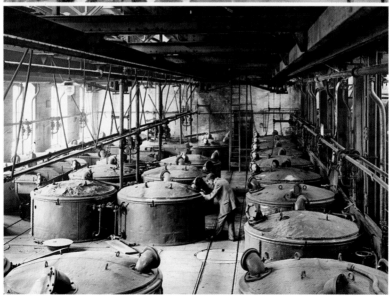

Left: an enlarged photograph of the edge of Vincent van Gogh's oil painting *Two Girls*. On

aniline greens such as China green, aniline yellows and oranges (called Hansa yellows), red lakes, or artificial alizarin pink, eosin-based geranium lake, aniline browns, and Lithol reds.

the right is an area covered by the frame, where the original pink of the dresses was protected from light; on the left is the bluish color seen today. The paint contains eosin, suggesting that the pigment used was geranium lake (above).

Most of these, unfortunately, were far from being as stable as their mineral-based precursors. For example, the bright pink geranium lakes Vincent van Gogh bought through his brother, Theo, in 1888 and 1889 have turned pale blue in many of his paintings. The rose lakes used by Paul Gauguin have also turned irremediably blue. Methyl violet, a violet lake, merely produced a fugitive color. The inks and pastels made with it were hardly lightfast. The painter James Ensor used these methyl-violet chalks in his pastel drawings. Their hues, once vivid, have completely faded, as may be seen at the edges of the drawings, which were covered by protective mats and have remained bright violet. Countless brushstrokes of countless other painters from the neo-Impressionist and Fauve schools have been similarly damaged. Over time, however, the unstable colors ceased to be manufactured. In the first half of the 20th century, new

organic pigments—thio-indigo violets, phthalocyanine blues and greens, diazoic yellows, quinacridone reds—progressively replaced the fragile lakes that had been made from the early synthetics. These new pigments were often more costly but very resistant to light, fluctuations in temperature, and humidity.

In tandem with the invention of new paints came an explosion in research on color theory and the study of how colors are perceived. Just as Chevreul's concepts of complementary colors and his categories of tint, hue, and saturation influenced Seurat and the Pointillist and Impressionist painters, other scientific studies of color and light also had an impact on painters at this time. Ogden Nicholas Rood (1831–1902), an American physicist who studied and measured the brightness of colors, wrote a book titled *Modern Chromatics* in 1879 that inspired Camille Pissarro.

War divides the color industry

When World War I came in 1914, international commerce was blocked and nations were forced to develop domestic industries. So much of the dye in Europe was produced in Germany that the Allied textile industries, which employed hundreds of thousands of workers, had virtually nothing with which to dye their cloth.

In the United States, the shortage of colorants was so

Light, especially ultraviolet light, modifies the molecules in many colorants, which then lose their color. For this reason, paint gradually fades. This phenomenon affects the permanence of artworks as much as it does the walls of rooms in a house. Paint chemists are always seeking more lightfast products, and modern colors are labeled with information about their relative permanence. Below: a 1903 box of English dye samples, designed to test for lightfastness. The tops of the sample threads were protected by a covering strip; the other halves were exposed to light. Even the paper beneath the exposed samples was discolored by light exposure.

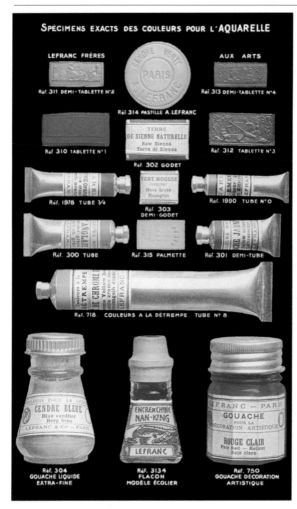

SPÉCIMENS EXACTS DES COULEURS POUR L'AQUARELLE

LEFRANC FRÈRES

AUX ARTS

Réf. 311 DEMI-TABLETTE N°2

Réf. 313 DEMI-TABLETTE N°4

CENDRE VERTE
PARIS
A LEFRANC

Réf. 314 PASTILLE A. LEFRANC

Réf. 310 TABLETTE N°1

TERRE
DE SIENNE NATURELLE
Raw Sienna
Terra di Sienna

Réf. 312 TABLETTE N°3

Réf. 302 GODET

Réf. 1978 TUBE ¾

VERT MOUSSE
Moss Green
Moosgrün

Réf. 303
DEMI-GODET

Réf. 1990 TUBE N°O

Réf. 300 TUBE

Réf. 315 PALMETTE

Réf. 301 DEMI-TUBE

DE CHROME

Réf. 718. COULEURS A LA DÉTREMPE. TUBE N° 8

CENDRE BLEUE
Blue verditer
Berg biau
LEFRANC & Cie — PARIS

Réf. 304
GOUACHE LIQUIDE
EXTRA-FINE

ENCRE DE CHINE
NAN-KING
LEFRANC

Réf. 3134
FLACON
MODÈLE ÉCOLIER

LEFRANC — PARIS
GOUACHE
POUR LA
DÉCORATION ARTISTIQUE
ROUGE CLAIR
Pale Red — Hellrot
Rojo claro

Réf. 750
GOUACHE DECORATION
ARTISTIQUE

Color samples, a tool for identifying and matching tints and shades, are as old as the dyer's trade. Many color merchants and analysts assemble valuable reference collections of archival and historical samples, as well as modern ones. The great Forbes collection, comprising 6,200 pigments and ancient colorants, survives, albeit dispersed among several institutions. Left: 19th-century pigments, lacquers, and varnishes.

marked that the printing of banknotes was temporarily halted for lack of green ink. In 1916, German-owned dye factories built on French soil were expropriated and nationalized as the Compagnie National des Matières Colorantes et des Produits Chimiques (National

L eft: powdered color samples and varnishes from the late 19th century. Ready-to-use colors came into use in the 18th century, but pig bladders made inconvenient and fragile storage containers. In 1841, the American painter J. Goffe Rand patented a tube made of sheet tin. The following year, the English firm of Winsor & Newton changed the patent by improving the cap and put tube colors on the market. The 19th century saw other innovations in paint manufacture, including the industrial grinding of pigments and the use of fats and paraffins as additives. Both of these inventions improved consistency and uniformity of products, especially oil paints. Henceforth, one could butter a canvas with colors, and all would flow on in the same smooth manner. Binders evolved at the same time. Linseed oil, which yellows as it ages, was replaced by poppy-seed oil, which remains colorless, but has a different character. With linseed oil the color deposited on the canvas becomes smooth and even as it dries; with poppy-seed oil it retains the brushstroke, which creates a sense of texture and relief. The stroke appears more nervous and the hand of the artist more visible. The Impressionists knew just how to exploit this change to the fullest.

Company of Colorants and Chemical Products). In England, the British Dyestuffs Corporation and Levinstein and Co. were formed.

Indigo and madder, high-quality dyes available at good prices, had been adopted to dye military uniforms in the 18th century, especially by the English and French armies. During World War I, a large volume of production was devoted to the dyeing of uniforms: *feldgrau* (field gray) and synthetic indigo for the Germans, khaki and natural indigo for the English, natural indigo and madder for the French. In 1914, the woolen trousers of French infantrymen were still dyed in natural madder. This market in military clothing was significant to the madder industry until 1915, when economic and social conditions changed. Madder is now ten times more

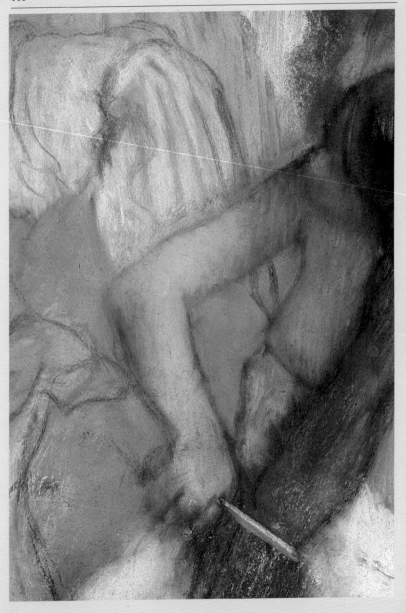

By the late 19th century, researchers in dyes, optics, art, and psychology were all grappling with ways to classify colors. Chevreul published *On Colors and Their Applications to the Industrial Arts* in 1864; Rood published *Modern Chromatics* in 1879; in 1915 the American Albert Munsell published the *Atlas of the Munsell Color System.*

The expression "pastel tone" indicates a soft, pale color, such as that found in a pastel drawing. The word pastel comes from *pastillus,* Latin for a small loaf or block. A pastel is a compacted powdered pigment to which white mineral and a binder are added. When a pastel is used on a textured paper, particles of color are transferred, forming tiny clumps. Light striking these is constantly reflected from one particle to another, becoming charged with color before reflecting outward in a perfectly diffused manner. The pastel artist can thus create delicate nuances of color and vaporous effects. The remarkable luminosity of pastel led color specialists to use it for their charts and the first color wheels. Far left: detail of a pastel drawing by Edgar Degas, 1890; near left: detail of a pastel by Maurice-Quentin de La Tour (1704–88). Above: a box of Foinet artist's pastels, c. 1930.

expensive than synthetic alizarin, and soldiers prefer to blend into a landscape. Under the pressure of modern warfare, the traditional red trousers of the French infantryman were replaced by a blue made from natural indigo that made a less visible target. After the war's end in 1918, the Allies acquired the German patents for dyes as spoils of war, which restimulated their own dye industries.

The industrial landscape after the war was radically changed. The United States, England, France, Japan, and Italy became mass exporters of synthetic colors. Chemical industries were founded all over the world (India, Australia, South Africa), representing so many markets lost to German chemistry, which struggled to reorganize. In 1925, the first cartel of the colorant industry, the German firm of IG Farben, formed under the aegis of BASF. England followed suit the following year, establishing Imperial Chemical Industries Ltd, or ICI. In France, the manufacture of colorants was reorganized by the Kuhlmann firm.

In 1934, a new family of colorants was discovered, the phthalocyanines, copper-based pigments that today provide essential, intense blues and greens with great coloring power and good coverage. These intense blues came to supplant even the popular ultramarine and Prussian blue in industrial applications.

Uncontrolled expansion

In 1939, on the eve of World War II, Germany was once again active in dye manufacture, producing 36 percent of the total world production of 1913. But it was far surpassed on the world market by the United States, which was now producing dyes and pigments at a rate of 1,600 percent of the total 1913 figure. The pace of international research and manufacture did not let up. The onset of a world war once again acted as a stimulant to work in applied chemistry; many of the large chemical manufacturers, including IG Farben, BASF, and Bayer in Germany and ICI in England, devoted considerable efforts to war-related research, from chemical weapons to plastics and penicillin. The German companies, especially IG Farben, were

The rarest, most precious colors have always been imported from exotic places. Indeed, Brazil owes its name to a dye. In 1500, the Portuguese navigator Pedro Alvares Cabral visited the land then called by Europeans Terra de Vera Cruz. Struck by the abundance of valuable brazilwood he found there, he rebaptized it Brazil. Europe was an eager market for its dyes. Later, the lands that had once produced natural dyes became markets for synthetic colorants. Today, from Fez to Khartoum dyers use products from France, the United States, Germany, or Japan. Below: a tin of French acid blue 93. Opposite: a 1929 advertising poster by Müller-Kludt for German pigments evokes the romantic Indies.

deeply implicated in war crimes, and in 1945 the Americans occupied and dismantled it, removing machines and documents as war spoils.

Around 1950, BASF reviewed the group of patents it held on colored organic molecules; although the survey was not completed, 350,000 patents were counted, of which 3,500, belonging to twenty-two chemical families, are still actively exploited. Synthetic indigo remained the most popular color, especially for work clothes. No amount of natural indigo cultivation could satisfy the postwar demand for the blue denim work clothes called blue jeans (whose name is a corruption of *bleu de Gênes,* or Genoa blue) and the gray-blue worker's garments popularized by Mao Zedong in China. Meanwhile, in the paint markets, indigo was overwhelmed by copper phthalocyanine for blues and greens. But new technological niches continued to appear ceaselessly, such as that for pearlescent pigments and luminophors for color television screens. In parallel, artists and color theorists continued to generate new systems of color theory. One of the most interesting is that of the Bauhaus painter Josef Albers, who published *Interaction of Color* in 1963.

Currently, the color industry is declining in Germany and the

Near left: Chinese workers wear shades of blue and blue-gray, dyed with synthetic indigo.

Among the most recent inventions in the field of pigments are the pearlescent and irides-cent colors. There are several processes for making these. The 1980 Merck process contains flakes of mica coated in titanium oxide; that developed in 1990 by BASF contains flakes of aluminum coated with hematite. The coated flakes create a so-called interference effect when light strikes them. Pearlescent paints thus combine two types of coloration (selective absorption and interference color) with the diffusion of light by the edges of the flakes. This set of effects produces pearlescence. Far left, above: a microphotograph of nacreous paint. Pearlescent colors are popular for cars. Below left: a robot paints a car. The synthetic pigments used in car paint are expensive, so colors are usually limited to those most economical. The base color is usually an inexpensive pigment with good opacity, such as ocher. More costly pigments, such as the pearlescents, are added for nuances.

United States. Much of the world market in synthetic colors is controlled by Japanese companies, although ICI in England and CIBA in Switzerland are also very productive. Japan has made a specialty of new natural colorants that are dramatically less toxic and less environmentally damaging than the older synthetics. These are particularly valued for use in foodstuffs and medicines.

Coloring foodstuffs

Dyes are traditional in certain foods. We expect mint- and pistachio-flavored candies to be green, butter to be yellow, preserved cherries to be red. The industrial practice of tinting foodstuffs is widespread. Thanks to

Industrial paints have specific functions. These include the protection of metals against corrosion, particularly since the rise in metal construction during the Industrial Revolution. Steamships and battleships, railway stations and viaducts, I-beams and window frames are all painted metal. Marine painting must resist salt water and sun, and has antifouling properties: the use of toxic copper or tin pigments prevents barnacles and other creatures from attaching themselves to ships' hulls. Far left: workers paint a tanker. A paint for roads and floors can be formulated to resist abrasion; one for stealth aircraft may be designed to diminish infrared or radar signals.

Artificial ultramarine, the pigment heir to Guimet blue, colors plastic objects well. Polymers are always a bit yellow, and blue pigment offsets this through the optical blueing effect. Near left: myriad consumer products use the same brand of pigment in different strengths to convey different—and well-researched— impressions. This blue is free of heavy metals and potentially dangerous molecules, and so is popular for use in food and beverage containers.

nontoxic food dyes, commercially produced meats have become redder, smoked sausages are an appetizing russet, and shrimps and prawns are a brighter pink than nature made them.

This use of dyes may not be universally pleasing, but research has made it clear that food color strongly influences the consumer's perception of its taste. Foods are dyed to make up for a loss of color during processing and packaging, to compensate for seasonal variations (or variations in the same batch), to color pale or colorless food, and to reinforce certain specific orientations of taste. Products to accelerate the reddening of peach skins are sprayed on the fruit while it is still on the tree. Fruit is picked before it is ripe for easier handling; but it already looks appetizing.

Synthetic food dyes have often been suspected of being carcinogenic or mutagenic, and governments are increasingly reluctant to permit their use. The Japanese are in the forefront of experiments with the cultivation of algae for dyeing. Natural colorants such as carotenoids and anthocyanins in combination with algaes may provide a full spectrum of food dyes that will be tolerated in the decades to come. For the time being, Canary Island cochineal and sea archil, known under their code names of E 120 and E 121, as well as caramel and red ocher, are still in use in foods.

Colorants used in dyes and paints are usually suspended in nonaqueous mediums. Dyes for foodstuffs must mix well with water and undergo specialized testing. Interestingly enough, in Western culture the color blue is rarely considered to make food appetizing. Right: a blue food dye is tested for solubility.

Natural and unnatural colors: the future of colorants

Recently, the consumption of pigments and dyestuffs has risen considerably, driving further research and develop-

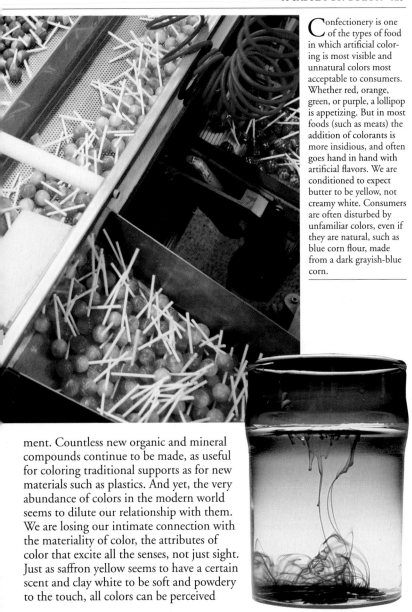

Confectionery is one of the types of food in which artificial coloring is most visible and unnatural colors most acceptable to consumers. Whether red, orange, green, or purple, a lollipop is appetizing. But in most foods (such as meats) the addition of colorants is more insidious, and often goes hand in hand with artificial flavors. We are conditioned to expect butter to be yellow, not creamy white. Consumers are often disturbed by unfamiliar colors, even if they are natural, such as blue corn flour, made from a dark grayish-blue corn.

ment. Countless new organic and mineral compounds continue to be made, as useful for coloring traditional supports as for new materials such as plastics. And yet, the very abundance of colors in the modern world seems to dilute our relationship with them. We are losing our intimate connection with the materiality of color, the attributes of color that excite all the senses, not just sight. Just as saffron yellow seems to have a certain scent and clay white to be soft and powdery to the touch, all colors can be perceived

according to their nature. Colors are not assessed only according to degrees of hue, brightness, or level of saturation, but are hot or cold, dry or wet, silky or rough, even aggressive or soothing.

Computer technology, with its arsenal of high-resolution screens and color printers, has greatly increased our distance from colors. The average human observer can readily distinguish some 100,000 colors; what are we to think of new systems and programs that claim to offer us a range of hundreds of millions of colors—and perhaps even more tomorrow? It is difficult at present to measure the effects of this inflation. We are nevertheless justified in fearing a certain confusion between the virtual, which is but coded information, and

B elow: the color standard, an essential work tool for certain professions, is a collection of scientifically chosen samples. It is used to identify or match a specific shade or to present a range of products to consumers. Manufacturers of paints, fabrics, papers, and inks produce color standards; researchers and analysts use them to measure everything from the colors of apricots ripening to geological strata.

a visual reality in which we maintain an affective relationship with the materials themselves.

In a period of flux and expansion, it is not surprising to see the revival, here and there (for example, in the persuasive vocabulary of marketing and advertising), of the antique colors, drawn from the manuscripts and treatises of the past: ocher, oxblood, cinnabar, carmine, auburn, azure, buff, tan, russet, chartreuse, cresson, scarlet. These colors bear history not only in their names but in their very molecules; they are the heirs of art, craft, and popular tradition. They remind us that pigments and dyes have affective and symbolic attributes, too, which are probably a bit neglected in our day.

Can color be measured? A number of modern systems have been devised for classifying colors. Most widespread are the one developed in the United States by the Inter-Society Color Council and the National Bureau of Standards (ISCC-NBS) in 1915 (revised in 1943) and the one devised by the Commission Internationale de l'Eclairage (CIE) in 1931. Colors are characterized according to three parameters: length of the dominant wavelength, level of saturation, and brightness. The first determines the hue (red, blue, green, etc.). The second determines the strength or intensity of the hue—for example, whether a red is pale pink or bright fire-engine color. The third measures on a scale of increasing tonality from white through gray to black. A color wheel represents one of these three parameters. Any perceived color can thus be represented in a three-dimensional graph, known as a colorimetric model. To each color, three numerical coordinates are assigned. A color is measured with an industrial colorimeter that calculates the three coordinates by illuminating the colored surface and measuring the wavelength of the light received.

Overleaf: commercially produced violet, rose, lavender, and blue pigments.

DOCUMENTS

"Drawing gives shape to all creatures, color gives them life.
Such is the divine breath that animates them."
Denis Diderot (1713–84)

The history of colors

An appreciation of colors is as old as civilization. The use of pigments and dyes is so universal in human culture that we scarcely notice it. Yet colors were once among the most precious and expensive of substances.

Powdered red ocher

Franco Brunello's monumental study of the history of dyes begins with the earliest known use of natural ochers, in the Palaeolithic caves of France and the burial sites of the Upper Great Lakes, in North America.

Some years ago it was fashionable to talk about a "red ocher culture" in the region around the Great Lakes of North America, where Wisconsin, Michigan, Iowa, Illinois, Indiana, Ohio, and Ontario are today. Even there, remains have been found of the custom of red ocher burial.

[In Europe,] excavations in the Paleolithic glacier area have brought to light sharpened pieces of ocher, cut like pencils or crumbling flakes, as well as flat dishes where the material was ground up. All this has given rise to the idea that not only were corpses and pictures on the interiors of caves painted, but other things came in for their share of colored decoration. The use of color in those far distant times was more general than we think. It goes a long way towards confirming what S. Pietsch has advanced in his book on prehistoric chemical technology: that man in the Ice Age was looking for colors in certain ocher quarries that have been brought to light. Iron oxide ochers are common enough in chalky areas, and...were already in use towards the end of the Mousterian culture (c. 30,000 BC). Then, with the extinction of the Neanderthal race and the appearance of the Cro-Magnon, colored ocher began to be used extensively.

André Leroi-Gourhan has reported that the quantity and intensity of the ocher in some prehistoric stations are nothing short of surprising. On the

Previous page: pigments being ground in an early 20th-century factory.

rocky floor of the grotto at Arcy-sur-Cure there is a carpet-like layer of violet-red ocher. It ranges from 10 to 15 cms. in thickness. In all, the total weight of the ocher is several hundred kilograms, brought from a quarry on the opposite side of the river, about a kilometer away.

There is no way of knowing what all this ocher was intended for. Perhaps it was a storehouse for the first dyers. It may have been the status symbol of the chief of the tribe. Or it may have been put there just to satisfy the cave dwellers' esthetic sense. All we know is that before the raw materials could be used they had to be reduced to powder by crushing with suitable pestles of bone or slate. Then, depending on their ultimate purpose, they were mixed with either fat or water. If used for painting, they were applied with the fingers or brushes made from strips of skin or feathers...

[We may speculate] that prehistoric man painted his face and other parts of his body just as the Aboriginals of Australia and the Indos of Mato Grosso do, and that he painted his weapons in the same way as the Eskimos of Alaska. Possibly, too, in prehistoric times, they painted their skins or the barks of plants...

If it is unclear that there existed Paleolithic dyers who applied mineral colors, it is even more uncertain how they used vegetable coloring matter. Unfortunately, the perishability of vegetable coloring matter has left no traces for us to deduce any information from. On the contrary, it is known that colors extracted from plants were used by Neolithic man, living in a mild climate and in a world rich in vegetation. In fact, the New Stone Age

is characterised by a change in climate accompanied by a new civilization.

Franco Brunello,
*The Art of Dyeing in the
History of Mankind*, 1968,
translated by Bernard Hickey, 1973

The dye trade

In the Middle Ages, dyes were as rare and valuable as spices, and traveled to Europe along the same routes. Fortunes were made and lost in the textile industry and the international shipping that supported it.

BUSINESS

Few merchants could survive by trading in a single item. The varying needs of different economic regions led to the organization of diversified trade. The lands to the north lacked sunshine and wanted wine. The wine-producing countries were generally short of grain. Wool came from England, Spain, Languedoc, or Provence, while alum came from the East or from Italy, and

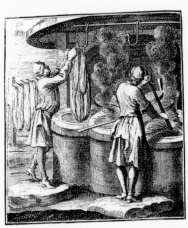

Dyers at work, in an 18th-century engraving.

the dyes—woad, indigo, saffron, cochineal, khermes, and *roccella* or *orseille*—from a variety of places. Although this situation encouraged reciprocal trade among marketplaces and rotating cargoes, it did not necessarily mean that every single merchant diversified…

Although vital to the West, a product like alum from Asia Minor was heavy and expensive to transport, costing some 16 percent of the buying price of the alum itself. Although partially remedied by the large variety of goods exported to Constantinople and the Black Sea, the imbalance in the flow of trade was further complicated by a financial imbalance. Profits from the sales made in the East could be only partially reinvested in the purchase of alum, the production and price of which were controlled by Genoa. Thus, it was essential to find a complementary cargo in the East that was not only heavy but also costly. The answer was spices, particularly pepper, although the major center for the latter was Alexandria rather than Constantinople. Similarly expensive but light to carry were the exotic dyes. Although Western dyes were perfectly adequate for everyday life and nobody would have dreamed of replacing woad with its Oriental equivalents, nevertheless, the costly purple and indigo were highly prized. And last, there was silk. Its high price—ten to twelve times that of pepper, weight for weight—reduced the cost of the transport to something like 0.5 percent.

The Genoese shippers balanced out their journeys in the following way: on the way to the East they carried moderately heavy merchandise of good value; on the return to Genoa they carried heavy goods of low cost, rounding out the cargo with light but costly goods.

From the thirteenth century, this attempt to balance weight and price led to return cargoes that themselves engendered regional redistribution. Flemish cloth was exchanged in Italy for products from the Orient, which were then resold by Bruges to London, Lübeck, Cologne, and Paris. It was traded at the Champagne fairs or in Paris for French or Burgundian wine destined for non-wine-producing regions on the North Sea and the Baltic. In Russia it was exchanged for the wood needed by the naval shipyards on the Channel and the Atlantic, for honey produced in the West, or for highly prized furs. During a period when the climate was becoming cooler, these costly furs became a very precise and subtle expression of social position among the upper classes. The flow of trade to the West brought ermine for the dignitaries at the papal court, sable for the Parisian magistrates, and squirrel for the Hamburg merchants. In exchange, cargoes of the violet woolen cloth produced in Brussels, marbled brown cloth from Saint-Omer, vermilion cloth from Arras, and purple striped cloth from Ghent traveled to the markets of Bergen and Novgorod.

And it was not only Flemish cloth. Exported from Bordeaux and La Rochelle, wines from Guyenne and Aunis were exchanged for wool and cloth from England, fabrics from the rural weavers of Normandy, dried fish from the Channel and the North Sea, and cereals from the Paris basin and the Polish plains. The wine convoys did not depart empty from either London or Bruges. When, in the fifteenth

century, the English first attempted to export the products of their expanding cloth industry, they knew that they could be sure of return cargoes of wine from Gascony, iron from Spain, and dyes from the East.

Jean Favier,
Gold and Spices: The Rise of Commerce in the Middle Ages, 1987, translated by Caroline Higgitt, 1998

A red dye worth rubies

Until the invention of synthetic dyes, all the red colorants—archil, madder, brazilwood, murex, and cochineal—were expensive and greatly prized. Cochineal dye has been in use since the empire of ancient Egypt. In the 1500s, discovery of sources in Mesoamerica brought untold wealth to the Spanish, who guarded the secret of its manufacture well.

COCHINEAL: THE GOLD
THAT DID NOT GLITTER

A color plant, a mollusk, or a scale insect does not announce, through its leaves, fruits, or glands, the presence of any dyestuff. Only the dyer knows that, through his chemical manipulations, brilliant and hardy colors can be derived from the often unattractive natural materials. One day in the middle of the 1700s, the crew of one of the Caribbean's most feared pirate ships learned that both colorful and pecuniary riches could be hidden in very humble dress. They sighted a large Spanish ship outside the coast of Honduras with a presumed load of gold and silver intended to enrich the Spanish crown, a circumstance of ownership that they decided to change rapidly by catching up with and boarding the ship. The Spaniards were quick and managed to avoid their pursuers.

In their haste to escape, the longboat was left behind and was captured by the pursuers. The pirates' disappointment over having captured only the longboat filled with worthless bags of dried brown grain quickly changed to happiness when they realized that the contents consisted of the "scarlet grain"—the fabulous, expensive raw material for the red dyestuff carmine!

At the time of this event the origin of the "scarlet grain" was still unknown in Europe. However, rumor had it that the Spaniards got it, along with other precious goods, far away in the mysterious countries on the other side of the Atlantic.

THE AREAS OF ORIGIN AND
THE EARLY USE OF COCHINEAL

The valuable but outwardly insignificant small grain was nothing other than dried females of the insect family *Dactylopius,* long called cochineal. Despite the fact that cochineal had been introduced to Europe before the end of the 1500s, uncertainty about the true nature of the dyestuff reigned long into the 1700s. The cause was simple enough. For the Spaniards, the sought-after good was of the greatest economic importance and they did everything they could to keep its existence and production a secret. Various written Spanish sources from the 1500s give evidence of the sensitive nature of the substance. Early works kept silent or were directly misleading about actual conditions. Later, what were for the most part correct descriptions, remained unnoticed or not believed. In fact, the Spanish authorities encouraged this lack of knowledge, making it more difficult for foreigners to gain a collective picture of the

manner of production and work methods used in cochineal factories.

The cochineal scale insect originates in South and Central America, where the Indians already used the carmine color for dyeing textiles in 1000 BC. When the Spaniards went to Mexico in the early 1500s, the dyestuff became frequently used. From Mexico its use spread to other countries, including Peru. The old Aztec term for the color was *nochezli,* which the Spaniards changed to *cochinilla.* Eventually the French form of the word, *cochenille,* became the most used…

RED FROM THE OTHER SIDE OF THE OCEAN

The Latin American countries' original production of cochineal should have been limited in scope and only intended to meet the needs of domestic textile production. After the Spaniards arrived, large-scale production of the valuable dyestuff was introduced and it eventually became one of the most important sources of income for the colonial power, aside from the export of silver. It has been calculated that between the years of 1758 and 1858, no less than 27,000 tons of cochineal were shipped out of Mexico. The picture of the extent of cochineal production becomes even clearer if data about the size of the plantations is considered. Each plantation consisted of no less than 50,000 cactus plants. The increasing demand was partly because the European and the Asian dye works discovered that Mexican cochineal had

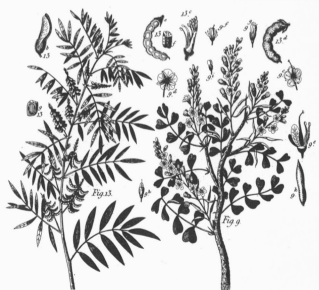

Left: logwood, or American brazilwood (*Haematoxylon campechianum*); right: the indigo plant (*Indigofera tinctoria*).

a higher content of actual dyestuff than the Polish and Armenian color scale kermes insects which had been used up to that time.

Thus, export was to Europe alone. In the 1580s, cochineal was transferred with loads of silver from Acapulco on the Tehuantepec isthmus to Manila on the Philippines. The dyestuff was also found in China from the time of the emperor Kang-Hsis (1662–1722). This far-sighted ruler was not only the promoter of the first great Chinese map and a great literary encyclopedia of over 5,000 volumes, but he was also the one who gave the French and British the right to conduct trade between China and the Occident. He was aware that *Ko-tcha-ni-la* was a product of a Latin American insect and that it was introduced by the Europeans. The carmine color went (and still goes) under the name of "foreign root," *Yang Hung. Yang* actually means ocean, so the expression could also be translated as "red from the other side of the ocean." Compare this to our word ultramarine (the blue gemstone lapis lazuli, from the other side of the ocean).

THE SPREAD OF THE COCHINEAL
SCALE INSECT TO NEW AREAS

The Spaniards brought the dried cochineal insect to Europe where the carmine dyestuff was then extracted, packed, and sold to waiting consumers. To ensure sole right to the product, the Spanish government prohibited all forms of import of living scale insects to the European continent.

Despite constant prohibitions that included a ban on exporting the mother strain of cochineal from Mexico to bordering Latin American areas, by the end of the 1700s, breeding had spread across the borders of the country to Guatemala, Brazil, and to the Indonesian island of Java. Later, plantations were also started on several of the West Indian islands, in Algeria, and on the Canary Islands. The monopoly that the Spaniards had ever since Cortéz conquered Mexico in 1519 was thereby broken, and the consumers could be supplied with the cochineal dyestuff from a number of different markets: the French from Veracruz, the Dutch from Java, and the English from India.

Gösta Sandberg,
*The Red Dyes: Cochineal, Madder,
and Murex Purple, A World Tour
of Textile Techniques,* 1994,
translated by Edith M. Matteson

The ever-changing artist's palette

Some of the pigments used by artists today are nearly identical to those used in the ancient world. Lead white and green earth are both still popular, side by side with modern synthetics such as ultramarine and Prussian blue. Other traditional colors have been superseded by new versions that are less toxic or more lightfast.

Pigment is the very essence of paint. Regardless of the vehicle that is used to adhere it to the substrate, pigment selection is based on one simple criterion. The colorant must be the right hue. Once that factor is met, the artist can compare it to other available pigments of a like hue, and determine the one that is best suited for the project at hand. The final selection may be based on opacity, cleanliness, vibrancy, and of course, permanence.

Ever since the first prehistoric artist picked up a smoldering chunk of charcoal from the fireplace to draw on the cave wall, mankind has striven to produce better art. Each artist from that

point on has faced the same question: "What materials will work the best for what I am trying to do?" In the case of early man, the answer was found in plants, dirt, and other available materials of the right color that could be crushed, ground or squeezed, and applied to the painting. In today's world we have at our disposal an incredible number of materials in a vast array of hues.

From these, for use in artwork intended to last, we can choose colorants with an emphasis on permanence. If a painting's characteristics are to remain consistent for generations to come, we cannot remain indifferent to the fact that certain pigments are going to fade. Such pigments should not be incorporated into a palette based on decisions made by artists centuries ago. Old choices should be continuously compared to new alternatives, with selections based on current information. Similar reasoning can be applied with regard to the characteristic of pigment toxicity.

There are pigments that have survived for centuries as reliable and safe colorants. Some of the inorganic pigments used since prehistoric times, such as the ochers and bone black, are still in use today. Along with these, we long ago made room on the palette for their refined counterparts, synthetics such as mars colors (iron oxides) and carbon black. We also have replaced many pigments on the palette, both naturally occurring and synthetic, with newer inventions. These additions and changes have collectively yielded improvements in color consistency, durability, safety, and range.

However, change does not come without skepticism and reluctance. Max

Doerner reflected on this issue in his circa 1921 book, *The Materials of the Artist:* "It is often heard said among artists that the old masters had no 'chemical' pigments, and for that reason their pictures are so well preserved. This, however, is a misconception, for the old masters had lead white, Naples yellow, vermilion, copper and sulfur colors, etc. The reason for the greater permanency of the old pictures lies in the fact that they were built up in a correct, craftsmanlike manner."

The acceptance of new pigments for use in painting has always been subject to differing opinions. Then and now, as each new colorant appears, it ranges from rapid embracement to disdainfulness. A pigment may be readily used by some based solely on hue, while the more cautious will inquire as to its permanence. Historically, the latter group gained this information from the fate of the former. Innovators, at their own risk, proved or disproved the archival merit of materials. Followers could then couple this information with the aesthetic and working attributes of the new pigment to see if it met their criteria. However, the rate at which a new pigment gained acceptance was often greatly accelerated if it filled a previously vacant color space, regardless of other criteria.

This procedure of evaluating pigments formerly required generations, as time was the most reliable indicator of lightfastness. The careful artists of each time period used past experience to create the most permanent paintings of their day. However, with modern test methods, this no longer is the case. It is now the pigment and artists' material manufacturer's role to provide

this information concurrent with the introduction of a new colorant…

WHY SOME PIGMENTS
ARE NO LONGER AVAILABLE

Many of the historical colors have become obsolete for a variety of reasons. Today's pigments are not made with the artist in mind, but for the production of industrial coatings, such as house paints, appliances, and automotive paints. For this reason when a color is out of favor, or replaced by a cleaner, more lightfast pigment, production of the older pigment can be halted almost immediately…

Toxicity may also cause a pigment to fall into disfavor. Pigments made from lead or mercury, such as Naples yellow or vermilion, can be poisonous and may have inadvertently killed many early artists. It is believed that Vincent van Gogh's mental illness and suicide may have been due, in part, to his frequent use of true Naples yellow. Many of these very toxic pigments were replaced by the cadmium family of pigments, which in turn are yielding to better choices in the evolution of pigment selection.

Although cadmium is less toxic than lead and mercury, it is still a heavy metal with an uncertain future due to continued regulatory concern.

From *Just Paint: Historical Materials,*
Golden Artist Colors, Inc., issue 6,
December 1998

EXCERPTS FROM THE HISTORY
OF TWO YELLOWS

Pigment definition

Orpiment is a yellow arsenic sulfide (As_2S_3) and realgar is a red arsenic sulfide (AsS or As_4S_4). Both pigments have been used in their natural and artificial forms. In the *Colour Index* (1971) orpiment is CI Pigment Yellow 39, nos. 77085, 77086. Realgar is not listed…

Archaic and historical names

Orpiment. The Greek for orpiment, used by Theophrastus in the fourth century BC and by later Greek writers, was *arsenikon.* It was identified with *arsenikos,* male, from the belief that metals were of different sexes. The word is related to the Persian *zarnikh,* which is based on *zar,* the Persian for gold. The Latin term *auripigmentum* or *auripigmento* (literally, gold paint) used by Pliny in the first century referred to the color and also to the fact that it was supposed to contain gold; this is the origin of the modern name…

Realgar. The Latin term used by Pliny was *sandarach,* which became the name *sandaraca* used by Agricola who also referred to it as *rosgeel.* The name realgar comes from the Arabic *rahj al ghar,* powder of the mine…

History of use

In ancient Egypt orpiment and realgar were included in New Kingdom (sixteenth to eleventh century BC) offering lists. Realgar has not been found on objects, but lumps of raw realgar and orpiment pigment were found in a fourteenth-century tomb. Both were used in Egyptian cosmetics…

In ancient Mesopotamia both orpiment and realgar are listed in Assyrian medical texts. Orpiment was found mixed with beeswax on an eighth-century BC Assyrian writing board from Nimrud. Cakes of orpiment were found in the palace of Sargon II of about the same date. A lump of orpiment was reported from the Hittite (thirteenth to

eleventh century BC) remains in Zinjirli in Anatolia.

Realgar was used by Scythian and Sarmatian tribes (seventh to second centuries BC) in the area north of the Caspian Sea.

Although the classical writers were well acquainted with orpiment and realgar minerals as pigments, medicines, and poisons, few occurrences of the pigments have been reported on Greek objects...

Although orpiment has not been a common pigment on European works of art, it was used from the ninth-century *Book of Kells* to late nineteenth-century impressionist paintings.

Medieval artists used orpiment imported from Asia Minor, and it was listed as an item in African–Genoese trade in the twelfth century. Theophilus described its use in the eleventh century. Orpiment has been identified on Norwegian wooden altar frontals, polychrome sculpture, and folk art objects, including a crucifix. Orpiment and realgar were used in twelfth- to sixteenth-century icons from Bulgaria, Russia, and the former Yugoslavia. It was found in the early fifteenth-century palette of Jan van Eyck...Venice was well situated as a European source of pigment supplies as it was a port for trade with the East and a center of the cloth-dyeing industry...Orpiment was used by J. M. W. Turner in late eighteenth- and early nineteenth-century oil paintings and oil sketches... Tintoretto (Jacopo Robusti, 1518–1594) made spectacular use of orpiment as well as realgar on some of his paintings...In the Western Hemisphere orpiment has been identified on several eighteenth-century American oil paintings... Orpiment has been found on a seventeenth-century painting from Peru.

Realgar has been identified with confidence on only a few works of art other than the Tintoretto occurrences cited above. Single examples are from an eleventh- to thirteenth-century manuscript from Central Asia and a fifteenth-century Armenian manuscript. Realgar has been reported on Bulgarian icons dating from the Middle Ages to the Renaissance, and on Indian sixteenth- to seventeenth-century paintings. It was found on a painting by Titian (Tiziano Vicelli, c. 1480/1490–1576), paintings by Jean Chardin (1699–1779), and on an anonymous seventeenth-century American portrait painting. The brevity of this list may be some indication of the rarity of the pigment, but it may also reflect the limited identification methods available until recently for realgar.

Dates of use

Orpiment, both natural and artificial, was used until the end of the nineteenth century. Because realgar has been so rarely identified, no definitive statement can be made about its use. Realgar's last known documented uses are in an eighteenth-century French painting and in a late-eighteenth-to nineteenth-century English pastel color box...

Color and spectral reflectance

Orpiment is usually described as a lemon or canary yellow or sometimes as a golden or brownish yellow. Realgar is described as aurora-red to orange-yellow, Munsell notation 9.1YR 7.1/11.6...

Toxicity

The toxicity of arsenic sulfide pigments has been known since early times. Strabo described a *sandarach* mine in Northern Anatolia where the mortality of the

workers was so high that only criminals were sent there. Artificial orpiment is extremely poisonous because of the presence of arsenic trioxide, a more soluble, and thus more toxic, compound than the sulfides.

The toxic properties of orpiment have been used to advantage to repel insects. A recipe for treating Chinese book rolls with orpiment for this purpose is described in a fifth-century treatise. Beginning in the sixteenth century in the Kathmandu Valley of Nepal, manuscript paper was coated with orpiment and yellow paper is still produced in the same way in Kathmandu...

Chemical composition

Orpiment is arsenic trisulfide (As_2S_3) and realgar is arsenic sulfide with the formula variously given as AsS, As_2S_2, and As_4S_4. Realgar is known chemically as arsenic disulfide (As_2S_2)...Orpiment and realgar are naturally occurring minerals both belonging to the monoclinic crystal system. Artificial orpiment (king's yellow) has the same composition as the mineral. It appears that other arsenic compounds can occur with the two more well-known minerals...

Preparation

Naturally occurring orpiment and realgar minerals were prepared by grinding and sometimes also levigation. The difficulty of powdering orpiment was mentioned [in the fifteenth century by Cennino] Cennini, although he appears to have been referring to the artificial material, which would not have been as difficult to grind as the mineral.

The Arab alchemists referred to the realgar orpiment as "the two kings" but it is unclear if this is the source for the term king's yellow for artificial orpi-

ment...Pliny, in the first century, described orpiment as a natural pigment, as opposed to being manufactured, evidently the earliest mention of the fact that an artificially prepared pigment existed. Cennini...referred to orpiment as "an artificial material...made by alchemy."...In the nineteenth century, dry-process orpiment was made by sublimation of a mixture of sulfur and arsenic trioxide (As_2O_3).

Little is known about the history of artificial realgar. [A] seventeenth-century Paduan manuscript...describes melting, cooling, and grinding orpiment to get "red orpiment." George Field noted that there were native and manufactured varieties of realgar in England in the early nineteenth century...

At present, synthetic arsenic trisulfide (As_2S_3) can be prepared by fusing arsenic or arsenic trioxide (As_2O_3) with sulfur. Heating a mixture of pyrite (FeS_2) and arsenopyrite (FeAsS) will yield a mixture of orpiment and realgar by sublimation. These methods yield impure mixtures, which must be further purified. Arsenic trisulfide also results when hydrogen sulfide is passed through a hydrochloric acid solution of arsenic trioxide; this product is very toxic because some arsenic trioxide always remains.

Synthetic realgar (AsS) is prepared by the same sublimation methods by varying the proportions. It can also be produced by fusion of sulfur and arsenic in the presence of carbon. One method of preparation is by heating orpiment with arsenic. There are other methods for preparing both compounds, but they are not used on a commercial scale...

from Elisabeth West FitzHugh, *Artists' Pigments: A Handbook of Their History and Characteristics,* vol. 3, 1997

Antique color recipes

In the ancient and medieval world, dyers and artists guarded their recipes for procedures and techniques as trade secrets. Some of these old recipes for dyeing, making paints, applying gilt, and preparing inks have been preserved. Unfortunately, their technical vocabulary is difficult to translate and many ingredients are impossible to identify or to find today.

Most medieval recipe collections are transcriptions of ancient Greek or Roman treatises. The authors, who assembled their notes without regard for order or coherence, were often scholars with little practical experience. Often the same collection will contain several recipes for making the same color. The compilers occasionally "enhanced" these formulas by adding varied and sometimes totally useless ingredients.

TO MAKE A VERDIGRIS GREEN

If you wish to make a Rouen green, take some leaves of the purest copper you can find, and cover them with the best lye. Put them in a pot that has never been used, then fill it with very strong vinegar. Cover the pot, seal it, and put in a warm place for two weeks. Then uncover the pot, place the sheets on a wooden plank, and set [the green patina] to dry in the sun...

TO MAKE CERUSE AND MINIUM

If you want to make either red or white minium, take a pot that has never been used, and put sheets of lead in it. Fill the pot with very strong vinegar, cover and seal it. Put the pot in a warm place and leave it for a month. Next, take the pot, uncover it, and shake out the deposits around the sheets of lead into a ceramic pot, and then place the ceramic pot on the fire. Stir the pigment constantly, and when you see it turn as white as snow use as much of it as you like; this pigment is called basic white lead, or ceruse. Then take whatever is left on the fire, and stir it constantly until it becomes red like minium. Remove it from the heat and allow it to cool.

Mappae clavicula (A Little Key to the World of Medieval Techniques),
11th or 12th century

TO MAKE VERMILION RED

If you want to make the color cinnabar, take sulfur (there are three kinds: white, black, and yellow), and grind it on a dry stone. Add to it half as much mercury, weighed on a scale. After mixing it carefully, put it in a glass flask and cover it with clay, stopping the opening so that the gas does not escape, and put it near the fire to dry. Then set it on live coals, and when it begins to heat you will hear a noise inside, an indication that the mercury is mixing with the hot sulfur. When the sound stops, remove the bottle, open it, and take out the color…

TO MAKE BLACK INK

To make ink, cut some branches of blackthorn [buckthorn] in April or May, before it produces leaves or flowers, and gather them into bundles. Let them sit in the shade for two, three, or four weeks, until they have dried a bit. Using small wooden mallets, crush the branches against a harder wood and completely remove the bark. Put it immediately into a barrel filled with water. When you have filled two, three, four, or five barrels with bark and water, let them sit for a week, until the water absorbs all the sap from the bark. Then put this water into a very clean pot or cauldron, put it on the fire, and cook it. From time to time throw some bark into the pot so that any sap left in it will come out in cooking. Once finished, cook the remaining water until it is reduced by a third, then transfer it to a smaller pan and cook it

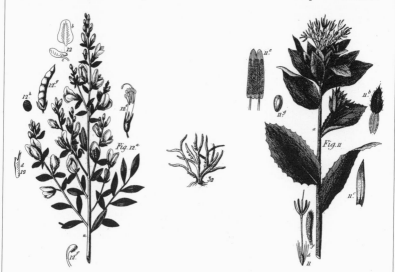

Dyes used in the ancient world included many obtained from plants. From left to right: the dried leaves of dyer's greenwood (*Genista tinctoria*) produce a yellow dye; the lichen variously called archil, orchil, or *orseille* (*Roccella tinctoria*) yields a red; safflower (*Carthamus tinctorius*) also produces yellow and sometimes red.

until it turns black and begins to thicken, taking care not to add any water other than the water mixed with sap. When it thickens, add a third as much pure wine, and put it into two or three clean containers, and cook it until you see a sort of skin form on the surface. Take the containers off the heat and set them in the sun so that the ink is purified of the red lees. Take carefully sewn small sacks made of parchment and pig bladders, pour the ink into them, and hang them in the sun to dry completely. Use [this ink] whenever you like. Dilute it with wine over charcoal, add a bit of atrament, and begin to write. If due to negligence the ink is not black enough, take a finger's width of atrament, heat it on the fire, and add to the ink. [*Atrament,* or *atramentum* is a hydrated iron sulfate that reacts to the tannins of which this ink is essentially composed, making a ferrogallic black ink.]

<div style="text-align:right">

Theophilus
(Roger of Helmarshausen),
De diversis artibus (*On Divers Arts*),
12th century
</div>

TO MAKE AN EXCELLENT
ULTRAMARINE BLUE

Take lapis lazuli and grind it fine on a porphyry stone. Then make a mass or paste of the following ingredients: for a pound of lapis, 6 ounces of Greek pitch, two of mastic, one of spike or linseed oil, and half an ounce of turpentine; bring it all to a boil in a pot until almost melted, then filter and gather the product in cold water. Stir and mix it well with the powdered lapis lazuli and let sit for a week or so. The longer it rests, the better and finer the blue will be. Next, knead the paste with the hands, sprinkling it with warm water; the blue will come out with the water. The first, second, and third rinsing should be done separately. When you see the blue fall to the bottom of the container, throw out the water and keep the blue. [The difficulty rests in extracting only the blue element, the lazurite, from the minerals that make up lapis lazuli.]…

TO MAKE YELLOW

This recipe was copied and anthologized many times over the centuries, until it became completely incomprehensible.

Cook the *vercande* [possibly a vegetal dye] well in clean, clear lye; add a little verdigris and dilute the bloodwort; the more verdigris you add, the redder it will be[?]; namely, two parts verdigris to five parts *vercande;* then add warm or boiling gall and you will be satisfied.

<div style="text-align:right">

Libri colorum
(*The Book of Colors*),
compiled by Jean Lebègue,
15th century
</div>

TO MAKE PURPURIN, OR *OR MUSSIF*

Purpurin is the color with which the color gold is made for painting and writing. To make it, melt a pound of fine tin, and when it is melted, take the liquid off the fire and add ten ounces of liquid silver [mercury]; mix well until it

Two artist's assistants grind pigments.

forms a paste, then take a pound each of well-ground sulfur and sal ammoniac. Incorporate this into the paste of tin and mercury, and grind them well together in a mortar or another vessel made of wood or stone, but not brass. Then put this substance into a flask that is well-sealed [stoppered] at the mouth or plastered, so that the seal sticks up one or two fingers'-width. Then put it on the stove, over a low heat in the beginning, then a little higher, using a small rod to tap the side of the flask to remove what is stuck to the glass. And when you see that it has turned yellow, take it off the heat and let it cool; you will have a beautiful purpurin, the color of gold. Afterward, grind it with lye, wash it with urine or lye, adding a bit of saffron, and dilute it with water and gum arabic, as you will see more clearly later on.

Les Secrets du Révérend Seigneur Alexis le Piémontois (*The Secrets of the Reverend Lord Alexis of Piedmont*), 1557

TO DYE PINEWOOD RED

This method is neither costly nor difficult. Take a large basket or bucket with many holes in the bottom. Fill it with horse manure, and put a second bucket or container without holes beneath the first, to catch the liquid that drains from the manure; then let it rot. If it takes too long to rot, you can help it by lightly sprinkling it with horse urine from time to time. With this simple liquid you will make your wood red by scrubbing it with a brush; two coats should suffice not only to paint the outside, but also to penetrate four or five layers, so that if these two coats are applied when the work is still rough-hewn, a worker can finish it off

and polish it without fear of exposing the natural color of the wood.

Albert moderne, ou Nouveaux Secrets éprouvés et licites (*The Modern Albert; or, New Tried and True Secrets*), 18th century

A RED-YELLOW FOR DARKENING GOLD

Take two pennies'-worth of saffron, a pea-sized amount of finely powdered alum, a nut of gamboge, and as much fine or Venetian lacquer, well-ground or dissolved; strain all this through fine white linen and put it in a clean vessel, adding enough iris green to give it a nice red-yellow color. Then dry this color in the sun…

TO DYE CLOTH PINK

Bring "sour water" [acidic medium], a good pound of tartar, and three pounds of alum to a boil; boil the cloth in this for an hour [to mordant it], then rinse it, cool it down, and rinse it again. When you are ready to put it in the dye, put fresh water in the bath: one bucket of "sour water" to two of plain water. Then take two ounces of cochineal, half an ounce of fenugreek, four ounces of gum arabic, two ounces or less of turmeric [curcuma], half an ounce of verjuice, four ounces of realgar [red arsenic], and a bit of tartar. Grind these ingredients very fine, separately, then mix them in a pot; if you leave out the cochineal, let it boil for fifteen minutes, then add the cochineal and let it boil a bit. Put the cloth in later, and let it boil an hour [in the dye], then take out the cloth, and it will be a fine pink.

Secrets concernant les arts et métiers (*Secrets of the Arts and Crafts*), 1792, 1819

Naming colors

The names of colors often reveal their origins—indigo from India; gamboge from Cambodia. Yet most ancient dyes and pigments have had many names. Some variants reflect the cultural traditions of a period or geographic area, but most derive simply from errors by compilers.

Fantastical and ambiguous names

The medieval alchemists, whose experiments were a blend of chemistry, medicine, and esoteric religion, used many of the materials of dyes and pigments in their research. Their work was known by four symbolic colors: the White, Yellow, Black, and Red Works. During the Enlightenment, scientists such as Antoine-Laurent Lavoisier sought to give substances more rational names.

Some [colors] were given intentionally obscure names; most were based on farfetched analogies. Thus, people spoke of oil of vitriol, butter of antimony, liver of sulfur, cream of tartar, sugar of Saturn. The 19th-century chemist Jean-Baptiste Dumas exclaimed, "The chemists seem to have borrowed the language of chefs!"

The number of names increased; five or six were given to the same substance. Potassium sulfate, a mordant used for dyeing, was known variously as *arcanum duplicatum, duobus* salt, vitriolic tartar, polychrest salt of Glazer, or potassium vitriol. At the end of the 18th century, scholars tried to create a new system of nomenclature intended to designate simple and compound elements unambiguously.

THE QUAGMIRE OF TERMINOLOGY

Through the ages, colors have often had symbolic values. The names used to identify them sometimes have reflected these attributes, rather than their chemical content or origin. For example, in classical texts on minerals,

A 19th-century bottle of carminum red pigment.

stones and metals tended to be named for their alleged therapeutic qualities or astrological connections: panther, hyacinth, dionysus, or heliotrope all are or were names of colors. It is risky to try to match these to current names. The same is true for many colors mentioned in the Bible, where "blood of Christ" or "heavenly blue" represent immaterial concepts as much as real hues.

Over the centuries, attempts have been made to designate certain colors as standards, and to name others in reference to them. In antiquity, painter's minium was a mercuric vermilion, but it was as bright as lead minium. Similarly, in the Middle Ages, a vermilion made from cochineal was said to be as bright as a mercuric vermilion. The authors of medieval treatises used the term *cenobrium,* or cinnabar, to designate mercuric vermilion and *minium rubeum* to designate red lead. *Minium album* or *album plumbum* designated lead white.

Many other names are likewise misleading. For example, there is very little actual silver in the color called "silver blue" by medieval illuminators. Rather, this is a blue-green pigment

A comparison of names of colors in three different eras.

Designation	Ancient Rome	Middle Ages	18th–19th Centuries
Pigment or Dye	*Pigmentum*	Color	Color
Egyptian blue	*Caeruleum Aegyptianum* or *caeruleum Puteolanum*	—	Alexandrian blue or Alexandrian frit
Natural ultramarine	*Lazurium*	*Azurum* or *Azzurrum ultramarinum*	Azure stone or ultra-marine azure or lapis lazuli
Indigo blue	*Indicum*	*Indicum* or *lulax* or bagadel indigo	Ynde or Bengal indigo
Malachite green	*Molochitis* or *chrysocolla*	*Melochites* or azure green	Mountain green
Verdigris	*Aerugo* or *aeris*	larin or *viride aeris* or *viride Graecum*	Verdigris or sea green
Orpiment yellow	*Arsenicum*	*Auripigmemtum* or *auripetrum*	orpiment yellow, mineral yellow, or orpiment
Minium red	*Sandaracca* or *plumbum ustum*	*Minium rubeum*	minium or red lead
Vermilion red	*Minium*	*Cinnabarim* or *cenobrium*	Cinnabar red or French vermilion
White lead	*Psimithium* or *cerusa*	*Minium album* or *biaccha* or *album Hispanicum*	Dutch ceruse or silver white
Chalk white	*Creta* or *creta alba*	*Album*	Trojan whiting, Meudon whiting, or Spanish whiting

made from copper acetate—copper being an impurity often found in silver-bearing ores.

Some names for pigments refer to their geographic origins. For example, the "indicum" in the treatises from antiquity and the Middle Ages, called "ynde" in 18th-century France, clearly names an indigo blue originating in Bengal. But 15th-century texts also mention an "indigo bagadel," or "indigo bagatelle," or even "bagadon," whose name comes from the fact that this dyestuff was brought to the West through the city of Baghdad. Another example is a "Smyrna green." Originally, this was the name for an earth green probably originating in Cyprus, which was exported through the Byzantine port of Smyrna. Over time, this name became "smaragdos," and ultimately "smaragd," which is now the German word for emerald (Italian and Spanish have similar words).

THE ETYMOLOGY OF RED

A color as expensive and precious as red has dozens of shades and tones, each with its own name.

Auburn: red-brown; from the Latin *alburnus;* in the 15th century, a whitish brown color; later, by association, a red-brown

Brazil: red; probably from the Spanish *brasa,* glowing coals; the color obtained from the dyewood of the same name

Burgundy: wine red; named for the wine from the Burgundy region of France

Carmine: a deep crimson; related to *crimson,* from *kermes,* from the Arabic *qirmizī*

Carnation: a light, rosy pink (sometimes also a deeper crimson color); from the Italian *carnagione,* complexion, or the coloring of the flesh

Carnelian: burnt-orange-red; from the Latin *carn-,* flesh; originally, a chalcedony stone with a deep red or flesh color

Cerise: a bright red with purplish tones; from the French word for cherry

Cinnabar: a warm red; red mercuric sulfide dye (the same material as vermilion); from the Greek *kinnabari,* from an older Oriental word

Coquelicot: poppy red; from the French word for poppy

Cresol: a brownish red; from the chemical name for coal tar, from which the aniline dye is made

Crimson: a deep red tending toward purple; from the medieval Latin *carmesinus* or *kermesinus,* a red dye made from kermes; *kermes* derives from the Arabic *qirmizī,* red dye

Damask: a grayish red; by association from either the pink damask rose or dyed damask cloth, both thought in the 15th century to have come originally from Damascus

Dragon's blood: a dark red; from the 14th-century name for a red dye obtained from a plant resin

Fuchsia: bright purple-pink; from the aniline dye invented in the 19th century and named for a flower of that color, which in turn is named for the 16th-century German botanist Leonhard Fuchs

Garnet: deep purplish red; from the color of the stone, which may derive from the French *pomegranate,* whose name means seedy apple, and whose seeds are dark red, or from the Latin *grana,* grains, referring to cochineal dye, which was sometimes thought to

be made from dried grains or berries

Madder: a medium to deep red; from an 11th-century Old English name for a local dye plant, later attached to the imported plant *Rubia tinctoria,* which produces a red dye; by association, the color alone

Magenta: a brilliant pink; an aniline dye invented in France and named for the 1859 battle of Magenta, in northern Italy, where the French defeated the Austrian army

Maroon: a brownish wine red; from the French *marron,* chestnut; in the 18th century, by association, chestnut color

Minium: earth red; from the Latin name for red lead, possibly from the word *mine,* or the old Celtic word for ore, metal

Mordoré: an 18th-century name for a dark brown red; from *mor,* moorish or dark, and *doré,* gilded

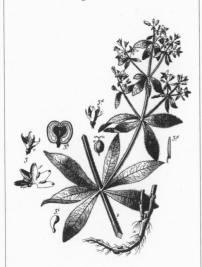

The madder plant (*Rubia tinctoria*), source of classic natural reds.

Murrey: purple-red; from the Latin *morum,* mulberry or blackberry; in the 14th century, a cloth dyed this color

Oxblood: a medium brownish red; from the color of beef blood

Pink: a pale red or rose color; origin uncertain, probably from the name of a flower of that color, the pink, whose petals are ruffled at the edges, or pinked (a 16th-century sewing term)

Puce: a brownish purple; from the 17th century, derived from the French word for flea; flea-color

Rose: a pink or pale red; from the Latin *rosa,* rose, the name of a flower of that color

Ruby: deep pink-red; from the Latin *rubeus,* red; originally the name for the precious stone, later also the color of that stone

Rufous: a brownish red, or rust color; from the Latin *rufus,* red

Russet: reddish-brown; from the Old French *roset,* a diminutive of *roux,* red; in the 13th century, a coarse homespun woolen cloth usually dyed that color; later, the color alone

Sanguine: a warm, rusty red; from the Latin *sanguineus,* blood color

Scarlet: a brilliant red with orange tones; probably from a Persian word, *saqalat,* a kind of rich cloth; by the 12th century in French (*escarlate*) and by the 15th century in English, came by association to mean a bright, costly red dye; later came to refer to the color alone

Stammel: in the 15th century, a coarse woolen cloth dyed red, from the French *estamel* (related to the Latin *stamin,* warp thread); later, a red color for such cloth, cheaper than scarlet

Vermilion: from the French *vermeil;* originally a cochineal dye once thought to come from a little worm (*verme*); by association, the red color of that dye

Modern artists confront color

Artists are concerned not only with the permanence and toxicity of colors, but also with their effect on the eye—and their symbolism and emotional power.

The ideal black

Like white, black is a color that does not exist in a pure form, except in the imagination; black pigments and dyes are made from very dark browns and blues. It took centuries to create fine blacks in dyeing, but good carbon black pigments, which absorb light well and approximate a true black, have been known since earliest antiquity. The color black has fascinated many artists, including the brilliant colorist Vincent van Gogh (1853–90).

c. March–September 1883
My dear Theo,

 …If you want to do me a great favor, send me by post some pieces of *craie de montagne* [a type of crayon]. That crayon has soul and life—I find conte crayon lugubrious. It's as if two violins had more or less the same appearance, but when you play them one produces a fine tone, while the other is useless.

 That crayon has a lot of resonance and tone. I'm tempted to say that

Despite the wide commercial availability of hundreds of industrially manufactured prepared colors in tubes, artists still mix the precise hues they want.

it understands what I want it to do, that it listens intelligently and obeys, while conte crayon is apathetic and unwilling. *Craie de montagne* has the true soul of a gypsy; send me some of this marvelous stuff, if it isn't asking too much…

April 1883
My friend Rappard,
…What do you think of this method of drawing in black and white? You make a drawing with either pencil or charcoal. You finish it as far as possible, but without worrying about weaknesses or imperfections in the effect. Once that is done, you put a little ordinary printing ink on a palette—a bit of brown, for example— as well as some white oil paint. After you've mixed the colors and the printing ink, which in its natural state is as stiff as tar, with some turpentine (not with oil, of course), you go back over the preliminary drawing—with a brush, naturally.

I've tried this just in the last few days. The principal ingredient is the printing ink, diluted with turpentine (you can thin it out enough to wash over the drawing, but if you leave it stiffer you can achieve the deepest shades of black)…

Vincent van Gogh

Black is an abstraction

All color is relative, according to the 20th-century modernist Jean Dubuffet (1901–85).

There are no colors, strictly speaking, only coloring materials. The same ultramarine powder looks infinitely different depending on whether it is mixed with oil, egg, milk, or gum arabic, and whether it is applied to plaster, wood, cardboard, or canvas (and depending, naturally, on the kind of canvas and its preparation—smooth or rough, more or less opaque). What there is beneath it always comes through a bit and affects the way it looks, even if this is hard to tell with the naked eye. The same colors, used without consideration, can appear insipid, while well-used they can appeared charged with meaning. Black satin, a black cloth, a spot of ink on paper, black shoe polish, black chimney soot and tar, and everything else that is black are qualified as BLACK. Black is an abstraction; there is no black, only black things. But they are black in different ways, for there is the question of brilliance, whether they are matte or shiny, polished, rough, fine, etc., which is very important.

Similarly, if the same black paint is applied by a painter with a soft or hard brush, with a spatula or a sponge, with a rag or a finger or a stick, and if it is applied in strokes and if these strokes are horizontal or vertical, hatched or slanted, or if it is wiped in circular movements or pulverized, and if it is granulated or smooth, it is not at all the same thing. And if it is black ground in oil or with glue, and if the powder is more or less fine, and if it is more or less liquid when used—all this is very important. This aspect and the means of applying a color are much more important than the choice of color itself. It is of very little import if one uses black or blue or red to paint a face or a tree, while it is much more important to use the chosen color in a certain way. Indeed, my painting could very well be painted with black alone without losing much—(not black and white, only

black)—but varied and applied in a thousand appropriate ways—whereas reproducing the same colors one sees, but without this variation, means nothing. The colors are less important than is generally believed—but the way in which they are applied means more.

Jean Dubuffet,
L'Homme du commun à l'ouvrage
(*The Common Man at Work*),
1973

Color theory, color practice

Josef Albers (1888–1976) was an influential teacher as well as a painter. He is especially known for his innovative approach to color theory.

The book *Interaction of Color* is a record of an experimental way of studying and of teaching color.

In visual perception a color is almost never seen as it really is—as it physically is. This fact makes color the most relative medium in art.

In order to use color effectively it is necessary to recognize that color deceives continually. To this end, the beginning is not a study of color systems.

First, it should be learned that one and the same color evokes innumerable readings. Instead of mechanically applying or merely implying laws and rules of color harmony, distinct color effects are produced—through recognition of the interaction of color—by making, for instance, 2 very different colors look alike, or nearly alike.

The aim of such study is to develop—through experience—by trial and error—an eye for color. This means, specifically, seeing color action as well as feeling color relatedness.

As a general training it means development of observation and articulation.

The Colors of the Rainbow, an illustration from an Enlightenment-era treatise on natural philosophy.

This book, therefore, does not follow an academic conception of "theory and practice." It reverses this order and places practice before theory, which, after all, is the conclusion of practice.

Also, the book does not begin with optics and physiology of visual perception, nor with any presentation of the physics of light and wave length.

Just as the knowledge of acoustics does not make one musical—neither on the productive nor on the appreciative side—so no color system by itself can develop one's sensitivity for color. This is parallel to the recognition that no theory of composition by itself leads to the production of music, or of art.

Practical exercises demonstrate through color deception (illusion) the relativity and instability of color. And experience teaches that in visual perception there is a discrepancy between physical fact and psychic effect.

What counts here—first and last—is not so-called knowledge of so-called facts, but vision—seeing. Seeing here implies *Schauen* (as in *Weltanschauung*) and is coupled with fantasy, with imagination.

This way of searching will lead from a visual realization of the interaction between color and color to an awareness of the interdependence of color with form and placement; with quantity (which measures amount, respectively extension and/or number, including recurrence); with quality (intensity of light and/or hue); and with pronouncement (by separating or connecting boundaries)…

COLOR RECOLLECTION—
VISUAL MEMORY

If one says "Red" (the name of a color) and there are 50 people listening, it can be expected that there will be 50 reds in their minds. And one can be sure that all these reds will be very different.

Even when a certain color is specified which all listeners have seen innumerable times—such as the red of the Coca-Cola signs which is the same red all over the country—they will still think of many different reds.

Even if all the listeners have hundreds of reds in front of them from which to choose the Coca-Cola red, they will again select quite different colors. And no one can be sure that he has found the precise red shade.

And even if that red Coca-Cola sign with the white name in the middle is actually shown so that everyone focuses on the same red, each will receive the same projection on his retina, but no one can be sure whether each has the same perception.

When we consider further the associations and reactions which are experienced in connection with the color and the name, probably everyone will diverge again in many different directions.

What does this show?

First, it is hard, if not impossible, to remember distinct colors. This underscores the important fact that the visual memory is very poor in comparison with our auditory memory. Often the latter is able to repeat a melody heard only once or twice.

Second, the nomenclature of color is most inadequate. Though there are innumerable colors—shades and tones—in daily vocabulary, there are only about 30 color names.

Josef Albers,
Interaction of Color,
1963

Further Reading

Agricola, G. *De re metallica*, L. H. Hoover and H. C. Hoover, trans., 1950.

Albers, J. *Interaction of Color*, 1971.

Angeloglou, M. *A History of Make-up*, 1970.

Aromatico, A. *Alchemy: The Great Secret*, 2000.

Augusti, S. *I Colori pompeiani*, 1967.

Bailey, K. C., ed. *The Elder Pliny's Chapters on Chemical Subjects*, 2 parts, 1932.

Balfour-Paul, J. *Indigo*, 1998.

Ballard, C. *Traité de mignature, pour apprendre aisément à peindre sans maître, avec le secret de faire les plus belles couleurs, l'or bruny, & l'or en coquille*, 1694.

Berthollet, C.-L. *Eléments de l'art de la teinture*, 1791.

Birren, F., Foss, C., et al. *Color*, 1980.

Bomford, D., and Roy, A. *Colour*, 2000.

Bouvier, P.-L. *Manuel des jeunes artistes et amateurs en peinture*, 1827.

Brédif, J. *Toiles de Jouy*, 1989.

Brock, W. H., and Porter, R., eds. *The Norton History of Chemistry*, 1993.

Brunello, F. *The Art of Dyeing in the History of Mankind*, 1973.

Caley, E. R. "The Leyden Papyrus X," *Journal of Chemical Education*, 3:10 (October 1926), pp. 1149–66.

Cardon, D. "New Information on the Medieval Woad Vat," *Dyes in History and Archaeology*, no. 10, 1992, pp. 22–31.

Caster, G. *Les Routes de cocagne: Le Siècle d'or du pastel*, 1998.

Cennini, C. *Craftsman's Handbook*, E. Neuhaus, trans., 1978.

Chapman, S. D., and Chassagne, S. *European Textile Printers in the Eighteenth Century: A Study of Peel and Oberkampf*, Pasold Studies in Textile History no. 1, 1981.

Chaptal, J. A. *L'Art de la teinture du coton en rouge*, 1807.

Chevreul, M. E. *The Principles of Harmony and Contrast of Colors and Their Applications to the Arts*. F. Birren, ed., 1987.

Crombie, A. C. *History of the Sciences from St. Augustine to Galileo (400–1650)*, 1959.

Crook, J., and Learner, T. *The Impact of Modern Paints*, 2000.

Da Cunha, C. *Le Lapis-Lazuli: Son histoire, ses gisements, ses imitations*, 1989.

Dambourney, L. A. *Recueil des procédés et d'expériences sur les teintures solides que nos Végétaux indigènes communiquent aux Laines & aux Lainages*, 1786, suppl., 1788.

D'Arclay de Montamy. *Traité des couleurs pour la peinture en email et sur la porcelaine; L'Art de peindre sur l'email*, 1765.

De Chaperon, P.-R. *Traité de la Peinture au Pastel*, 1788.

De Grandis, L. *Theory and Use of Color*, 1986.

Delamare, F., Hackens, T., and Helly, B., eds. *Datation-Caractérisation des peintures pariétales et murales*. European Postgraduate Course, PACT 17, CUEBC, 1987.

Delumeau, J. *L'Alun de Rome, XVe–XIXe siècle*, 1962.

Doerner, M. *The Materials of the Artist and Their Use in Painting with Notes on Their Techniques of the Old Masters*, 1984.

Dumas, J.-B. *Traité de chimie appliquée aux arts*, vol. 8: *Matières colorantes et teintures*, 1846.

Feller, R. L., Roy, A., and Fitzhugh, E. W., eds. *Artists' Pigments: A Handbook of Their History and Characteristics*, 3 vols., 1997, 1998.

Fox, R., and Nieto-Galan, A. *Natural Dyestuffs and Industrial Culture in Europe, 1750–1880*, European Studies in Science, History, and the Arts, vol. 2, 1999.

Gettens, R. J., and Stout, G. L. *Painting Materials: A Short Encyclopaedia*, 1966.

Gibbs, P. J., and Seddon, K. R. *Berberine and Huangbo: Ancient Colorants and Dyes*, British Library Studies in Conservation Science, vol. 2, 1998.

Greenberg, A. *A Chemical History Tour: Picturing Chemistry from Alchemy to Modern Molecular Science*, 2000.

Guineau, B., ed. *Pigments et colorants de l'Antiquité et du Moyen Age*, 1990.

Harley, R. D. *Artists' Pigments, c. 1600–1835: A Study in English Documentary Sources*, 1982.

Harris, R. M., ed. *Coloring Technology for Plastics*, 1999.

Hellot, J. *L'Art de la teinture des laines et des etoffes de laine en grand et petit teint; avec un instruction sur les débouillis*, 1786.

Herbst, W., and Hunger, K. *Industrial Organic Pigments: Production, Properties, Applications*, 1997.

Iversen, E. *Some Ancient Egyptian Paints and Pigments: A Lexicographical Study*, 1955.

Leggett, W. F. *Ancient and Medieval Dyes*, 1944.

Lemery, N. *Dictionnaire universel des drogues simples, contenant leurs noms, origines, choix, principes, vertus, étimologies, et ce qu'il y a de particulier dans les animaux, dans les végétaux et dans les minéraux*, 1733.

Le Pileur d'Appligny. *Traité des couleurs matérielles et de la manière de colorer*, 1776.

Malandin, G., Avril, F., and Lieutaghi, P. *Platéarius: Le Livre des simples médecines, d'après le ms. Bibliothèque Nationale de France fr. 12322*, 1990.

Mayer, R., and Sheehan, S. *The Artist's Handbook of Materials and Techniques*, 1991.

Merrifield, M. P. *Original Treatises Dating from the XIIth to the XVIIIth Centuries on the Arts of Painting*, 1849.

Miller, D. *Indigo from Seed to Dye*, 1984.

Nickell, J. *Pen, Ink, and Evidence: A Study of Writing and Writing Materials for the Penman, Collector, and Document Detective*, 2000.

Partridge, W. *A Practical Treatise on Dying*, 1823.

Perkin, A. G., and Everest, A. E. *The Natural Organic Coloring Matters*, 1918.

Philip, W. *A Booke of Secretes*, 1596 (on inks), J. C. Thompson transcr. and ed., in *Manuscript Inks*, 1996.

Piecquet, O. *La Chimie des teinturiers: Nouveau traité théorique et pratique de l'art de la teinture et de l'impression des tissus*, 1892.

Pliny the Elder. *Pliny Natural History*, H. Rackham and E. H. Warmington, trans. and ed., 1989.

Postlethwayt, M. *The Universal Dictionary of Trade and Commerce*, 1755.

Riddle, J. M. *Dioscorides on Pharmacy and Medicine*, History of Science Series no. 3, 1985.

Robertson, S. *Dyes from Plants*, 1979.

Rosetti, G. *The Plictho of Gioanventura Rosetti: Instructions in the Art of the Dyers which Teaches the Dyeing of Woolen Cloths, Linens, Cottons, and Silk by the Great Art as Well as by the Common*, S. M. Edelstein and H. C. Borghetty, trans., 1969.

Sandberg, G. *Indigo Textiles: Technique and History*, 1989.

———. *The Red Dyes: Cochineal, Madder, and Murex Purple*, 1994.

Silvestrini, N., and Fischer, E. P. *Color Systems in Art and Science*, 1996.

Smith, C. S., and Hawthorne, J. G. "Mappae Clavicula: A Little Key to the World of Medieval Techniques," *Transactions of the American Philosophical Society*, new series, 64:4 (July 1974).

Storey, J. *The Thames and Hudson Manual of Dyes and Fabrics*, 1992.

Theophilus (Rugerus, or Roger of Helmarshausen). *On Divers Arts: The Foremost Medieval Treatise on Painting, Glassmaking, and Metalwork*, 1979.

Thomas, A. W. *Color from the Earth: The Preparation and Use of Native Earth Pigments*, 1980.

Thompson, D. V. *The Craftsman's Handbook*, 1960.

———. *Materials and Techniques of Medieval Painting*, 1957.

Watin, J.-F. *L'Art du peintre, doreur et vernisseur*, 1773.

Zollinger, H. *Color Chemistry: Syntheses, Properties and Applications of Organic Dyes and Pigments*, 2d ed., 1991.

List of Illustrations

Key: *a* = above; *b* = below; *c* = center; *l* = left; *r* = right

Front cover: Box of pastels, private collection
Back cover: Pigments manufactured by the French Sennelier company
Spine: Tubes of Lefranc paint, private collection
1 Sennelier pigments
2 Green pigment
2ar Colored yarn samples from the Beauvais Tapestry Works, Paris
3 Detail of a palette belonging to Eugène Delacroix, Musée Eugène-Delacroix, Paris
3r Detail of a color chart of Sennelier pigments

4 Brown pigment
4r Parasols in Thailand, photograph
5r, 5l, 5b Details of color charts of Sennelier pigments
6 Yellow pigment
6ar Production of yellow paint
7 Dyed coconut fibers
7r Detail of a color chart of Sennelier pigments
8 Blue pigment
8r Balls of ultramarine blue, 19th century, Musée National des Arts et Traditions Populaires, Paris
9 Detail of a plastic bottle dyed with pigments from Holliday Pigments, England

9b Detail of a color chart of Sennelier pigments
11 Bottle of light madder lake, 19th century, Musée National des Arts et Traditions Populaires, Paris
12 Detail of a Coptic textile, Musée National du Moyen Age, Paris
13 Eye of Horus, detail of the *Stele of Taperet*, painted wood, Egypt, 22d Dynasty, c. 900–800 BC, Musée du Louvre, Paris
14 Ocher quarry in Roussillon, France
15 Block of red ocher, private collection
16 Wounded Bison, Palaeolithic cave painting, c. 15,000–10,000 BC,

Altamira, Spain
17 Room of the Bulls, reconstruction of a Palaeolithic cave painting from Lascaux, c. 15,000–10,000 BC, Musée des Antiquités Nationales, Saint-Germain-en-Laye, France
18–19 Palaeolithic cave paintings from the Pech-Merle cave, c. 25,000 BC, Lot, France
20 Ushabti of Ramesses IV, painted wood, Egypt, New Kingdom, Musée du Louvre, Paris
20b Pigment pot from the funeral chamber of Kha, Egypt, 18th Dynasty, c. 1400 BC, Museo Egizio, Turin, Italy

21a Nebamun hunting aquatic birds, stucco painting, Thebes, Egypt, 18th Dynasty, c. 1400 BC

21b Fragments of ocher and Egyptian blue found in the funeral chamber of Kha, Deir el-Medineh, Egypt, 18th Dynasty, c. 1400 BC

22 Hippopotamus, enameled clay from Thebes, Egypt, Middle Kingdom, 11th Dynasty, 2125–1985 BC, Musée du Louvre, Paris

23 Detail of a pectoral with scarab, Egypt, 1336–1327 BC, Egyptian Museum, Cairo

24a–25a Prisse d'Avennes papyrus, Egypt, 2600 BC, Bibliothèque Nationale de France, Paris

24b Fragment of an Egyptian shroud, painted linen, Egypt, 19th Dynasty, Département des Antiquités Egyptiennes, Musée de Louvre, Paris

25b Student's writing tablet, Egypt, New Kingdom, Musée du Louvre, Paris

26b–27b Mineral pigments used in Pompeii, Museo Archeologico Nazionale, Naples

27a Roman wall painting from the House of the Vettii, c. AD 70, Pompeii

28 Fragment of a glass vial containing madder lake from the Gallo-Roman town of Argentomagus, France, 2d century AD

29a Detail of a Roman wall painting using green earth (terre verte), Stabiae, near Naples, c. AD 10

29b Green earth (terre verte), Winsor & Newton collection, London

30–31 Detail of *Scenes of a Dionysiac Mystery Cult*, fresco, c. 50 BC, Villa of the Mysteries, Pompeii

32a Drinking glass,

c. 70 AD, southern Italy, Musée du Louvre, Paris

32b Alexandrian blue glass, 1st century AD, Musée Rolin, Autun, France

33 Top to bottom: realgar, Alexandrian blue, and litharge yellow pigments found near the island of La Planier, near Marseilles, France

34 Coptic weaving, Musée du Louvre, Paris

35l Dyeing yarn in Cappadocia, Turkey

35r Dyeing cloth in Cameroon

36 Empress Theodora and her court, mosaic, c. AD 545, church of San Vitale, Ravenna

37 Murex shell used for purple dye, drawing, 1757, Bibliothèque Municipale, Versailles

38 *Notre Dame de la Belle Verrière*, stained-glass window in the southern ambulatory, c. 1170, Cathedral of Notre Dame, Chartres, France

39 Textile merchants, miniature from a French illuminated manuscript, 15th century, Bibliothèque Nationale de France, Paris

40 Wolf, detail of an illumination from the *Book of Kells*, using two green inks made of copper and indigo, Ireland, 8th century, Trinity College Library, Dublin

41 Juggler, detail of a miniature in Ms. Lat. 1118, fol. 122v, late 10th century, Bibliothèque Nationale de France, Paris

42l Clothier and dyer, illumination in a medieval edition of Rabanus Maurus, *De universo*, Abbey of Montecassino, Italy

42a–43a Dried safflowers, private collection

43b Dried buckthorn berries, private collection

44l Madder root, Winsor

& Newton collection, London

44r A. Matthiole, engraving of madder from *Commentaires sur Dioscorides* (*Commentaries On Dioscorides*), 1642, private collection

45 Dyers, miniature in Jean de Ries's *Le Livre des propriétés des choses* (*The Book of the Properties of Things*), 1482, British Library, London

46a Dyers, miniature in *Precetti dell'arte della seta* (*On the Art of Silk*), Italian manuscript, 15th century, Biblioteca Medicea Laurenziana, Florence

46b Ball of pastel

47 Chunk of indigo from Benares, India, Colour Museum, Bradford, England

48 Medieval palette shell, 15th century, Chateau of Mehun-sur-Yèvre, France

49 Miniature, 15th century, Bibliothèque Nationale de France, Paris

50 Sight (*The Lady and the Unicorn* tapestry series), 15th century, Musée National de Moyen Age, Paris

51 Joseph of Arimathea, detail of an ivory sculpture, c. 1260–80, Musée du Louvre, Paris

52 Presumed portrait of Louis the Pious, king of France, illumination in Rabanus Maurus, *De laudibus sanctae crucis* (*In Praise of the Holy Cross*), 9th century, Bibliothèque Municipale d'Amiens, France

54–55 Samples of mineral and organic substances, miniature in *Le Livre des simples médicines* (*Book of Simple Medicines*), 14th-century manuscript, Bibliothèque Nationale de France, Paris

56 Manufacturing vermilion, engraving from

a 1561 edition of Georgius Agricola's 1530 text, *Dialogue on Mining*

57al French recipe for scarlet lake from *Les Secrets du Révérend Seigneur Alexis le Piémontois* (*The Secrets of the Reverend Lord Alexis of Piedmont*), 1557, private collection

57ar A. Matthiole, alembic, engraving from *Commentaires sur Dioscorides* (*Commentaries On Dioscorides*), 1642, private collection

57b Purified cochineal carmine, 19th century, private collection

58a Detail of Piero della Francesca, *Portrait of Sigismondo Malatesta*, oil on wood, 1450, Musée du Louvre, Paris

58b Magnification of a detail of Piero della Francesca, *Portrait of Sigismondo Malatesta*, showing yellow tin pigment, Ecole des Mines, Paris

59 Piero della Francesca, *Portrait of Sigismondo Malatesta*, oil on wood, 1450, Musée du Louvre, Paris

60 Léonard Limosin, *Orpheus before Pluto and Persephone*, painted glass-enamel plaque, 16th century, Musée National de Céramique, Sèvres, France

61a Plaque from a cross, champlevé enamel, late 12th century, Musée National du Moyen Age, Paris

61b Historiated casket of St. Thomas Becket, champlevé enamel on copper, late 12th century, Musée National du Moyen Age, Paris

62–63l Plate ornamented with the crest of the Duke of Ferrara, painted ceramic from Urbino, Italy, c. 1579, Musée National de

Céramique, Sèvres, France

63ar Platter from the Beauvais region, painted ceramic, 16th century, Musée National de Céramique, Sèvres, France

63br Painted ceramic jug from Urbino, Italy, c. 1540–50, Musée National de Céramique, Sèvres, France

64 The Visitation, illumination from the *Heures du maréchal de Boucicaut (Book of Hours of Marshal Boucicaut),* early 15th century, Musée Jacquemart-André, Paris

65a, 65b Details of illuminations from the *Heures du maréchal de Boucicaut (Book of Hours of Marshal Boucicaut),* early 15th century, Musée Jacquemart-André, Paris

66 Forty samples of indigo from India, Java, and Guatemala, 1756, Deutsches Textilmuseum, Krasfeld, Germany

67 Porcelain color wheel, Manufacture Nationale de Céramique de Sèvres, France

68 Mining alum, miniature, Bibliothèque Nationale de France, Paris

69 Arab merchants, miniature from Marco Polo, *Le Livre des merveilles du monde (The Book of Marvels),* c. 1412

70a Dried cochineal insects, 20th century, private collection

70b Gathering cochineal insects, detail of a watercolor, 18th century, National Archives, Mexico

71 Raphael, *Pope Leo X with Cardinals Giulio de' Medici and Luigi de' Rossi,* oil on panel, c. 1517, Galleria degli Uffizi, Florence

72–73 Anonymous painting of Venetian dyers, 1730, Museo Correr, Venice

74 Pig bladder, 19th

century, Musée National des Arts et Traditions Populaires, Paris

75 David Ryckaert, *Self-portrait,* oil on canvas, 1638, Musée des Beaux-Arts, Dijon, France

76–77a Chemistry laboratory, illustration in Denis Diderot and Jean le Rond d'Alembert, *Encyclopédie ou dictionnaire raisonné des sciences, des arts, et des métiers (Encyclopedia of Sciences, Arts, and Crafts),* 1763

77b Bottle of Prussian blue, 19th century, Colour Museum, Bradford, England

78a, 78b, 79a, 79b Dyeing cloth, rinsing cloth in the Bièvre River, washing cloth at the Gobelins Tapestry Works, dyeing silk, illustrations in Denis Diderot and Jean le Rond d'Alembert, *Encyclopédie ou dictionnaire raisonné des sciences, des arts, et des métiers (Encyclopedia of Sciences, Arts, and Crafts),* 1763

80 Detail of Georges de la Tour, *Le Tricheur à l'as de carreau (Cheater with the Ace of Diamonds),* oil on canvas, early 17th century, Musée du Louvre, Paris

81a Notes on yellow pigments from George Field, "Examples and Anecdotes of Pigments," in the *Practical Journal,* 1809, Courtauld Institute of Art, University of London

81b Ball of Indian yellow pigment, 19th century, Winsor & Newton collection, London

82–83 Printing and hot-pressing of wallpaper, early 19th century, Sèvres porcelain, Musée National de Céramique, Sèvres, France

84l Colorimeter invented by Michel-Eugène

Chevreul, Gobelins Tapestry Works, Paris

84r–85l Léon-Auguste Tourny, *Portrait de Chevreul (Portrait of Chevreul),* oil on canvas, 19th century, Musée d'Angers, France

85a Michel-Eugène Chevreul, chromatic color circle of dyed wool fibers, Gobelins Tapestry Works, Paris

85b Box of ultramarine blue pigment balls manufactured by J. B. Guimet, 19th century, private collection

86–87a Jean-Baptiste Huet, *La Manufacture de Jouy en 1806 (The Jouy Factory, 1806),* oil on canvas, Musée Oberkampf, Jouy-en-Josas, France

87b Printed cotton calicos, Paris

88l Léonard Schwartz, *Journal du laboratoire chez Isaac Schlumberger (Laboratory Journal of Isaac Schlumberger),* 1838, Musée de l'Impression sur Etoffes, Mulhouse, France

88r–89 Cotton-printing factory, c. 1835, Science Museum, London

90a–91a Handkerchief, printed cotton from the Blumer and Jenny company, late 19th century

90–91b Japanese-inspired cloth with butterfly motif, printed cotton on panel, Daniel Koechlin company, Musée de l'Impression sur Etoffes, Mulhouse, France

92a, 92b Title pages of Jean Hellot, *L'Art de la teinture des laines (The Art of Dyeing Wool),* 1786, and J. A. Chaptal, *L'Art de la teinture du coton en rouge (The Art of Dyeing Cotton Red),* 1807

93 Peruvian dyer, watercolor, 18th century, Palacio Real, Madrid

94–95 English indigo

factory in Bengal, photograph, c. 1877, Science Museum, London

96 Photograph of a modern paint factory, Winsor & Newton collection, London

97 Label from the British Alizarine Co., Ltd, Colour Museum, Bradford, England

98 Dyewoods from the Chevreul laboratory, Gobelins Tapestry Works, Paris

99l Shawl dyed with Perkin's mauve, 1862, Science Museum, London

99r Portrait of William Henry Perkin, Colour Museum, Bradford, England

100l Diagram of the chemical structure of benzene

100a–101a Aniline factory, engraving, 1886

100b Friedrich August Kekulé, photograph

102l Vial of alizarin, Colour Museum, Bradford, England

102r Dyed potato starch, magnification of an autochrome, Centre de Recherche sur la Conservation des Documents Graphiques (CRCDG), Paris

103 Louis and Auguste Lumière, *French soldiers during World War I,* before 1915, autochrome photograph

104–5 Samples of dyed wools from O. Piequet, *La Chimie des teinturiers (The Chemistry of Dyers),* 1892, private collection

106 Detail of James Abbott McNeill Whistler, *Arrangement in Gray and Black: Portrait of the Artist's Mother,* oil on canvas, 1871, Musée du Louvre, Paris

107 Detail of Jean Béraud, *Une soirée,* oil on canvas, Musée d'Orsay, Paris

108 White bed linens, photograph

109l Sheets of paper, photograph

109ar Label for Lutetia blueing, private collection

110 Label for indigo manufactured by BASF, 1903

111a BASF factory plant, 1910, Ludwigshafen, Germany

111b Indigo production vats at BASF, 1910, Ludwigshafen, Germany

112l Detail of Vincent van Gogh, *Deux petites filles* (*Two Girls*), oil on canvas, 1890, from "La Couleur," in *Cahiers du Léopard d'Or*, 1994

112r Bottle of geranium lake, Colour Museum, Bradford, England

112b–113 Box of English dye samples, 1903, Science Museum, Science and Society Picture Library, London

114l Lefranc pigments, lacquers, and varnishes, 19th century, private collection

114r–115 Samples of powdered pigments and varnishes, late 19th century, private collection

116 Detail of Edgar Degas, *Femme se coiffant* (*Woman Combing Her Hair*), pastel on paper, 1887–90, Musée d'Orsay, Paris

117a Box of pastels, c. 1930, private collection

117b Detail of Maurice-Quentin de La Tour, *Portrait de Nicole Ricard enfant* (*Portrait of Nicole Ricard as a Child*), pastel on paper, 18th century, Musée du Louvre, Paris

118 Müller-Kludt, poster for Farbenfabriken Otto Baer, 1929, Bibliothèque des Arts Décoratifs, Paris

119 Canister of acid blue 93, Kuhlmann Co., private collection

120a–121l Pearlescent paint, photograph, Ecole des Mines, Paris

120b–121 Robot painting a car

121r, Chinese workers, 20th century

122 Painting the tanker Sigma Kalon

123 Holliday brand pigments used in various consumer products, England

124–25a Production of Chupa Chups lollipops, Barcelona

125b Blue food coloring

126–27 Standard color sampler

128 Violet, blue, lavender, and rose pigments, Holliday Pigments, England

129 Pigments being ground at the Sennelier workshop in the early 20th century, Sennelier archives

131 C. Weigel, *Dyers at Work*, engraving, 18th century

134 Botanical illustration from J. G. Heck, *The Encyclopedia of Science, Literature and Art*, 1851

141 Botanical illustration from J. G. Heck, *The Encyclopedia of Science, Literature and Art*, 1851

142 Phillipe Galle, detail of *The Painter's Studio*, showing the grinding of pigments, engraving, Bibliothèque Nationale de France, Paris

144 Bottle of carminum red pigment, early 19th century, private collection

147 Botanical illustration from J. G. Heck, *The Encyclopedia of Science, Literature and Art*, 1851

148 La Ruche artists' workshop in Montparnasse, photograph by Paul Almasy, 1968

150 *The Colors of the Rainbow*, engraving in Abbé Haüy, *Traité élémentaire de physique*, (*Elementary treatise on Natural Philosophy*), 1806

Index

A

Acid blue, 119

Additives, 115

Agfa, 110

Agricola, Georgius, 56, 137

Albers, Josef, 85, 120, 150–51

Alchemy, 56–58, 75–76, 139

Aldehyde green, 99

Alembics, 57

Alexandrian blue, 22, 28, 29, 31, 33, 40, 49

Algae, 17, 124

Alizarin, 97, 98, 99, 101–2, 112, 119

Alkanet, 25

Altamira, cave of, 15, 16, 17

Alum, 48, 68–69, 80, 88, 91, 132

Alvares Cabral, Pedro, 70, 119

American fustet, 82

Anatolia, 138

Aniline, 98–103, 112

Animals, properties of, 43

Annatto, 82

Anthocyanins, 124

Antimony, 61

Antwerp blue, 76

Archil, 25, 98, 124, 141

Arsenic sulfide, 137, 139

Arsenic green, 82

Arsenic disulfide and trisulfide, 21, 22, 139

Artworks, *see* Painting

Atacamite, 22

Athanors, 57

Autochrome, 102

Azure blue, 39

Azurite, 26, 48, 49, 53, 64

B

Bacon, Roger, 43

Baldogean, 28

BASF, 101, 102, 105, 110, 119, 120, 121

Batik, 34

Bauxite, 17

Bayer, Friedrich, 102, 105, 110, 119

Benzene ring, 100, 101

Béraud, Jean, 107

Berthollet, Claude-Louis, 77, 109

Binders, 40, 115

Blacks, 49, 106, 107, 148–50

Bladder green, 74

Bleaches, 88, 109

Blueing, optical, 109, 123

Blumer and Jenny, 91

Book, oldest known, 23

Book of Kells, 40, 138

Boucicaut Hours, The, 64

Boucicaut Master, 64

Brazilwood, 47, 64, 74, 83, 98, 119

British Dyestuffs, 110, 115

Bronze color, 51

Brunello, Franco, 130–31

Buckthorn, 74

Bull's blood, 91

Burgundy violet, 82

Butlerov, Aleksandr, 100

C

Cabral, Pedro Alvares, 70, 119

Cadmium, 137

Calcite white, 20

Calico, 86–87, 89

Calligrams, 53

Candy, 125

Carmine, 76

Carotenoids, 124

Car paints, 110, 120, 121

Cassius, Andreas, 76

Cavendish, Henry, 76

Celadonite, 28, 29

Cennini, Cennino, 139

Ceramics, 62–63
Ceruse, 23, 32, 51, 140
Chaptal, Jean-Antoine, 26
Chardin, Jean-Baptiste-
Siméon, 85, 138
Chemical absorption,
35, 121
Chemistry, 56–58, 76–77,
80, 82, 139
applied, 97–127
organic, 100–101
paint, 113
Chemistry of Dyes, The
(Piequet), 105
Chevreul, Michel-Eugène,
27, 77, 80, 84, 98,
113, 117
Chierico, Antonio del, 64
Chigi, Agostino, 68
China green, 112
Chinese white, 84
Chintz, 87
Chlorine, 76, 109
Chlorite, 28
Chrome, chromium, 81–82
Cinnabar, 28, 31, 32
Clay, 15, 26
Cobalt, 23, 76
Cobalt blues, 82
Cobalt oxide, 61, 109
Cochineal, 25, 47, 48, 57,
70–71, 74, 102–3, 124,
133–35
Colorants, 14, 40, 124–26
Color classification, 41,
80, 117, 127
Color intervals, 80
Color perception, 105, 125
Color photography, 102
Colors:
antique, 127, 137–38
artificial, 110, 112, 139
brightness of, 113
evolution of, 40
history of, 130–51
law of contrasting and
complementary, 80, 113
naming, 144–47
primary, 81
symbolism of, 20, 22, 56
Color samples, 114–15
Color standards, 126
Color television, 120
Color theory, 120, 150–51
Color wheels, 67, 80, 127
Colour Index, 137
Columbine lake, 64
Computer technology, 126
Congo red, 103

Copper blue, 22
Copper green, 48, 53, 75,
82, 83
Copper oxide, 61
Copper resinate, 40, 51,
58, 64
Cosmetics, 137
Cotton, 86–91, 105
Couper, Archibald, 100
Courtois, Bernard, 82–83
Crocoite, 81
Crystals, 32

D

da Gama, Vasco, 70
d'Alembert, Jean le Rond,
76, 79
Dalton, John, 77
Davy, Sir Humphrey, 26,
77
De diversis artibus
(Theophilus), 51
Degas, Edgar, 117
Delft blue, 23
Denim, blue jeans, 120
Diazoic yellows, 113
Diazotization, 102
Diderot, Denis, 76, 79,
129
Dieppel, Johann Konrad,
76
Diesbach, 76
Dioscorides, 56
Doerner, Max, 136
Dragantum, 53
Drebbel, Cornelius, 76
Druggists, 74
Dubuffet, Jean, 150
Dyeing, 12, 24–25, 34–35
art of, 41–42, 92
recipes for, 46
treatises on, 43, 88, 105
wax-resist, 34
Dyes:
commerce in, 29, 32–33,
47–48
discoveries of, 76
early, 18–19
evolution of, 40–41
organic, 18
quality of, 43, 105
synthetic, 97–127
Dyewoods, 98
Dyeworks, 42–43, 45,
72–73, 78–79, 93, 131–33

E

Earths, 14–15, 16, 28, 29,
48, 75, 81

Egg tempera, 74
Egypt, 20–25, 137
Egyptian blue, 20, 33,
40, 49
Emblema, 27, 28
Emerald green, 39
Enamelwork, 60, 61
English greens, 82
Ensor, James, 112
Eosin, 112

F

Favier, Jean, 133
Fibers:
animal, 34, 35, 103
vegetable, 34, 35, 91
Field, George, 81, 139
Fischer, Emil, 100, 104
Fluorescent dyes, 109
Folium violet, 40, 48, 51
Food dyes, 124, 125
Forbes collection, 114
France, robes of the king
of, 46
Frescoes, 26–27, 30–31,
37
Fuchsin, 98–99, 104

G

Galen, 32
Galena, 23
Gamboge, 143
Gauguin, Paul, 112
Genoa blue, 120
Geranium lake, 112
Glass, 32
Glauconite, 28, 29
Glazes:
blue, 22, 23
transparency of, 51
Gobelins Tapestry Works,
78–79, 80, 84
Goethite, 15
Gold:
alchemy and, 76
gilding, 51
red-yellow, 143
Gold leaf, 64
Graebe, Carl, 101
Grana, 70, 74
Green disease, 17
Greenwood, 141
Griess, Peter, 102
Grisaille, 64
Guatemala, 67
Guimet, J. B., 85
Guimet blue, 109, 123
Gum arabic, 25, 53
Gum tragacanth, 81

H

Hair dyes, 109
Hansa yellows, 112
Hellot, Jean, 92
Helmholtz, Hermann
von, 105
Hematite, 15, 17, 26, 28,
32, 51, 53
Herculaneum, 25
Hieroglyphics, 20
Hofmann, August
Wilhelm von, 99, 100,
102
Hue, 80, 84, 113, 135
Huet, Jean-Baptiste, 86
Hugh of St. Victor, 43
Hydrogen sulfide, 139

I

ICI, 119, 121
IG Farben, 119–20
Impressionists, 113, 115,
138
Imprimatura, 74
India, 67, 86, 94–95
Indian yellow, 81
Indicum, 47
Indigo, 25, 34, 35, 37, 46,
47, 49, 51, 53, 64, 67,
86, 92–95, 103, 104–5,
110, 115, 119, 120
Indigotin, 47
Indirubin, 47
Industrial paints, 122, 123
Industrial Revolution,
82–85, 86, 89
Ink, 20, 23–24, 25, 141–42
Interference effect, 121
Iodine green, 99
Iron oxide, 15, 17, 61
Isidore of Seville, 43

J

Jarosites, 22
Java, 67
Jouy-en-Josas factory,
86–88

K

Kaolin, 15
Kekulé, Friedrich August,
100, 101
Kermes, 25, 37, 48, 64,
71, 76
Koechlin, Daniel, 88, 91
Koechlin, Samuel, 88
Kohl, 23
Kremnitz white, 84

Kuhlmann, Frédéric, 84, 119
Kuhlmann green, 84
Kurtz, P., 82

L

La Clef, Charles de, 85
Lady and the Unicorn, 50
Lakes, 28, 29, 35, 48, 56, 58, 64, 110
Lampblack, 24, 25
Lapis lazuli, 20, 40, 48, 49, 51, 53, 64, 75
Lascaux, cave of, 15, 17
La Tour, Maurice-Quentin de, 117
Lavoisier, Antoine-Laurent, 76–77
Lead oxide, 33
Lead white, 26, 48, 51, 74, 75, 82–84
Lebrun, Charles, 79
Lefranc & Bourgeois, 85, 110
Liebermann, Carl, 101
Light, diffusion of, 121
Light exposure, 113
Limonite, 15
Limosin, Léonard, 61
Linen, painted, 25
Linseed oil, 74, 115
Litharge yellow, 33
Logwood, 83, 98
Luddite riots, 89
Lumière brothers, 102

M

Madder, 24, 32, 35, 41, 44, 45, 47, 83, 86, 91, 98, 103, 115, 119
Magenta, 98
Maghemite, 17
Malachite, 22, 58
Manganese, 76
Manganese oxide, 15
Manuscripts, illuminated, 39, 40, 41, 49–51, 53, 54–55, 64
Mao Zedong, 120
Marine painting, 122, 123
Mars yellow, 82
Masticote, 58
Mauve, 98, 99
Merck process, 121
Mesopotamia, 137
Metals, properties of, 57
Metalwork, 61
Methyl violet, 112

Military uniforms, 92, 103, 115
Minerals:
 properties of, 43
 variables of, 33
Minium red, 48, 51, 56, 140
MLB, 102, 105, 110
Mordant, 25, 34–35, 45, 76, 88, 91
Mosaic gold, 57
Mosaics, 37
Mountain blue, 49
Müller-Kludt, 118, 119
Munsell, Albert, 117, 138
Murex, 19, 28, 35, 37
Mussif, 142

N

Naples yellow, 80, 137
Natural History (Pliny), 24–25, 43, 47
Nepal, 139
Nitrogen, 76
Notre Dame de la Belle Verrière, 38, 39

O

Oberkampf, Christophe, 86, 88, 89
Ochers, 14, 15, 16, 17, 18, 20, 27, 31, 32, 48, 75, 81, 97, 121, 124
Oil paints, 115
Orcin, 98
Orpiment, 22, 32, 41, 48, 51, 53, 57, 58, 137–39

P

Painting:
 figurative, 17
 lakes used in, 110, 112
 landscape, 20
 light and, 113
 mural, 25–26, 37
 pigments for, *see* Pigments
 religious, 20
 techniques, 74–75
Paint tubes, 115
Papyrus, 23–24, 40
Parchment, 40
Parisian blue, 76, 88
Paris violet, 99
Pastels, 117
Patent yellow, 81
Pech-Merle, cave of, 15, 18, 19
Perkin, William, 98, 99, 102
Persian blue, 39

Persian red, 91
Perspective, 59
Peru, 138
Phthalocyanines, 113, 119, 120
Piequet, O., 105
Piero della Francesca, 59
Pig bladders, 115
Pigments, 16–18, 127
 chromium-based, 82
 commerce in, 29, 32–33, 47, 69, 74
 extraction of, 43
 grinding of, 49, 75, 115, 129, 142
 for painting, 48–49, 59, 135–39
 pearlescent, 120, 121
 recipes for, 53, 56, 140–43
 synthetic, 22–23, 139
 toxicity of, 58, 137–39
Pissarro, Camille, 113
Plastics, 123
Pliny the Elder, 24–25, 28, 31, 37, 43, 47, 137, 139
Polo, Marco, 69, 86
Polymers, 123
Pompeii, 25, 26, 27, 28, 30–31
Pompeiian red, 91
Poppy-seed oil, 74, 115
Porcelain, 22, 23
Potassium, 76
Pozzuoli blue, 33, 49
Precursors, 34
Priestly, Joseph, 76
Prisse d'Avennes papyrus, 23–24
Prussian blue, 76, 81, 119
Purple, 34
 imperial, 35, 37, 71
Purple of Cassius, 76
Purpurin, 142

Q

Quartz sand, 15
Quercitron, 82, 98
Quicksilver, 56
Quinacridones, 110, 113

R

Rand, J. Goffe, 115
Raphael, 71
Realgar, 21, 26, 33, 137–39
Renard and Franc, 98
resist-printing, 88
Robiquet, Pierre-Jean, 98
Roger of Helmarshausen, 50

Rood, Ogden Nicholas, 113, 117
Rose-madder lake, 40, 48

S

Safflower, 24, 43, 141
Saffron yellow, 39, 47
Sandberg, Gösta, 135
Sanguine, 15, 32
Saturation, 80, 81, 113
Scheele, Carl Wilhelm, 76, 80
Sea green, 81
Sennelier, 85
Sepia, 81
Seurat, Georges, 85, 113
Siberian red lead, 81
Siena, 15
Solferino, 98
Squid, 53
Stained glass, 38, 39
Strabo, 138

T

Tannins, 25, 41
Tapestries, 50, 78–79
Tattoos, 16
Terra rossa, 17
Terre verte, 18, 29
Textile industry, 40–48, 86–89, 102, 105
Textile rollers, 89
Textiles, 13, 19, 24–25, 34–35
 dyes in, 42, 143; *see also* Dyeing; Dyes
 polychrome, 34, 87
 printed, 86–91
Thénard, Louis-Jacques, 84
Thénard blue, 84
Theophilus, 50, 138
Theophrastus, 137
Thio-indigos, 110, 113
Tin chloride, 76
Tinctorial woods, 98
Tint, 80, 113
Tintoretto, 138
Tin oxide, 61
Tin yellow, 75
Titian, 138
Tornsole, 48, 53
Tourny, Léon-Auguste, 84
Tubières, Anne-Claude-Philippe de, 26
Tungsten, 76
Turkey red, 88, 91
Turner, J. M. W., 138
Tyrian purple, 48

U

Ultramarines, 82, 119, 142
Umber, 15
Unverdorben, Otto, 98

V

Van Eycks, 64, 138
van Gogh, Vincent, 112, 137, 148–49
Vauquelin, Louis-Nicolas, 26, 77, 81, 82
Vegetables, properties of, 43
Venetian red, 91
Venice, 139

Venice turpentine, 53
Verdigris green, 140
Verguin, François-Emmanuel, 98
Vermilion, 48, 53, 56, 57, 64, 75, 141
Veronese earth, 28
Vestorius, 32
Vibrations, optical, 64
Vincent of Beauvais, 43
Virgin, mantle of, 46
Viridian green, 82
Vitruvius, 28, 31, 35, 56

W

Wallpaper, 82, 83, 85
Watercolors, 81
Weights and measures, uniform system of, 77
Weld, 19, 28, 35, 58, 98
West Indies, 70–71, 74
Whistler, James McNeill, 107
Whites, 108, 109
Winsor & Newton, 84, 110, 115
Witt, Otto, 100–101
Woad blue, 44–47, 49
Woodblocks, 82

World War I, 113, 115, 119
World War II, 119–20
Writing, 53
Wurtz, Charles-Adolphe, 100

Y

Yellows, 80–82, 137–39, 142
Young, Thomas, 104

Z

Zinc whites, 82–83
Zuber, Jean-Henri, 82

Photograph Credits

AKG Paris, 30–31, 69, 72–73, 100a–101a, 100b, 111a, 131. AKG Paris/Paul Almasy, 148. All rights reserved, 28. Archives Sennelier, 129. Atelier de la Manufacture Royale des Gobelins de Beauvais et de la Savonnerie (Gobelins Tapestry Works), Paris, 2ar, 20, 22, 24b, 32a, 34, 50, 51, 58a, 59, 60, 61a, 61b, 67, 74, 80, 82–83, 84l, 98b, 106, 107, 116, 117b. Francis Bacon, Toulouse, 46b. Bibliothèque Nationale de France, Paris, 24a–25a, 39, 41, 49, 54–55, 68, 142. BIOS/Delabelle, 14. Jacques Boulay, 108. Bridgeman, Paris, 16, 21a, 45, 46a, 64. Jean-Loup Charmet, 118. P. and M. Chuzeville, 25a. CNAM, Paris, 85a. Collection of the authors, back cover, 15, 29a, 32b, 42a–43a, 43b, 44r, 48, 57al, 65a and b, 70a, 85b, 104–5, 109ar, 114–15, 117a, 119, 144, 150. Colour Museum, Bradford, England, 47, 77b, 97, 99r, 102l. Comoglio, Paris, 87b. Cosmos/Photo Researches/C. D. Winters, 125b. Courtauld Institute of Art, University of London, 81a. Dagli-Orti, 17, 20b–21b, 26, 27, 36, 38, 42l, 62–63l, 63br, 70b, 71, 86–87a. Deutsches Textilmuseum, Krasfeld, 66. Diaf, 6ar. Diaphane/Sennelier, front cover, 1, 3r, 5. Ecoles des Mines de Paris/F. Montezin, 58b, 120a–121l. Explorer Archives/Collection Bauer, 111b. Giraudon, 23, 84r–85l. Hoaqui/Huet, 35r. Hoaqui/Thibaut, 35l. Holliday Pigments/G. Larmuseau, 9, 123, 128. Patrick Léger/Gallimard, 2, 3, 6, 8, 126–27. M. Lorblanchet, 18–19. Magnum/Bruno Barbey, 121r. Rapho, 5. Rapho/Michel Baret, 122. Rapho/Françoise Huguier, 4r. Rapho/H. A. Segalen, 109l. Rapho/G. Sioen, 7. Roger-Viollet, 76–77a. Science Museum, London, 88r–89, 94–95, 99l. Sygma/B. Annebicque, 124–25a. Sygma/F. Pitchal, 120b–21. Tallandier, 103. A. Tchernia, 33. J. Vigne, 37, 52, 78a, 78b, 79a, 79b, 112l. Winsor & Newton collection, London, 29b, 44l, 81b, 96.

Text Credits

From Josef Albers, *Interaction of Color*. Copyright © 1963 Yale University Press. From Franco Brunello, *The Art of Dyeing in the History of Mankind*, translated by Bernard Hickey. English translation copyright © 1973 by Neri Pozza Editore. From Jean Favier, *Gold and Spices: The Rise of Commerce in the Middle Ages*, translated by Caroline Higgitt. English translation copyright © 1998 Holmes & Meier Publishers, Inc. From Elisabeth West FitzHugh, *Artists' Pigments: A Handbook of Their History and Characteristics*, vol. 3, 1997, © 1997 National Gallery of Art, Washington, D.C., reprinted by permission. From *Just Paint* issue 6, December 1998, Copyright © 1998 by Golden Artist Colors, Inc. Used with permission of Sterling Publishing Co., Inc., N.Y., N.Y.: from *The Red Dyes: Cochineal, Madder, and Murex Purple, A World Tour of Textile Techniques*, © 1994 by Gösta Sandberg, first published by Tidens Forlag, English translation © 1997 by Lark Books. From Elisabeth West FitzHugh, *Artists' Pigments: A Handbook of Their History and Characteristics*, vol. 3, 1997. Reproduced by permission of the National Gallery of Art, Washington, D.C. All rights reserved.

François Delamare, a chemist and metallurgist, specializes in the surface reactivity of materials. He also studies Roman and Gallo-Roman pigments and modern industrial paints. He is director of research at the Ecole des Mines, Paris.

Bernard Guineau is an expert in ancient colors and their uses. He is a physicist and research engineer at the Centre National de la Recherche Scientifique (CNRS). He has collaborated with historians from the Ecole Pratique des Hautes Etudes in studies of the history of pigments and dyes, the evolution of painting techniques, and developments in art conservation. He is the author of *Pigments et colorants de l'antiquité et du moyen age* (*Pigments and Dyes from Antiquity and the Middle Ages*), published in 1990 by Editions du CNRS.

Translated from the French by Sophie Hawkes

For Harry N. Abrams, Inc.
Editor: Eve Sinaiko
Typographic designers: Elissa Ichiyasu, Tina Thompson, Dana Sloan
Cover designer: Dana Sloan
Text permissions: Barbara Lyons

Library of Congress Cataloging-in-Publication Data

Delamare, François.
[Materiaux de la couleur. English]
Colors : the story of dyes and pigments / François Delamare, Bernard Guineau.
p. cm. — (Discoveries)
Includes bibliographical references and index.
ISBN 978-0-8109-2872-5 (pbk.)
1. Dyes and dyeing. 2. Pigments. I. Guineau, Bernard, 1935– II. Discoveries
(New York, N.Y.)
TP897.D3913 2000 00–25231
667'.2—dc21

Printed and bound in Italy
10 9 8 7 6 5

HNA
harry n. abrams, inc.
a subsidiary of La Martinière Groupe

115 West 18th Street
New York, NY 10011
www.hnabooks.com